BIRMINGHAM
FOOT SOLDIERS

BIRMINGHAM FOOT SOLDIERS

VOICES FROM THE CIVIL RIGHTS MOVEMENT

NICK PATTERSON

Charleston · London

THE
History
PRESS

Published by The History Press
Charleston, SC 29403
www.historypress.net

Images are courtesy of the author unless otherwise noted.

First published 2014

Manufactured in the United States

ISBN 978.1.62619.220.1

Library of Congress CIP data applied for.

To the God of Truth, who witnesses all the untold stories.

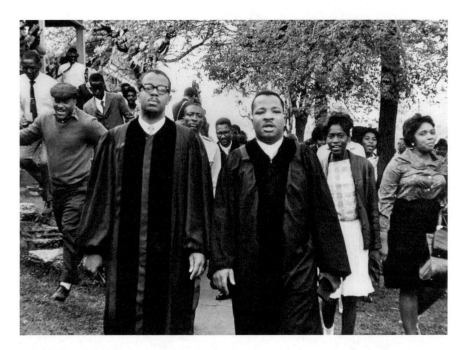

A.D. King (right), pastor of a Birmingham church and brother of Martin Luther King, and another minister lead foot soldiers in a protest. *Image courtesy of the Birmingham Public Library Archives.*

Foot Soldiers

The support grew to overwhelming proportions, overwhelmed the systems of jail and abuse and courts of illegitimate practice…really broke the back of segregation in Birmingham.
—Birmingham movement leader Fred Shuttlesworth, pastor of Bethel Baptist Church, founder of the Alabama Christian Movement for Human Rights

You can't lead if you don't have followers. Martin Luther King said that a number of times. You can't fill the jail cells up with the leaders.
—Horace Huntley, historian, former director of the Oral History Project of the Birmingham Civil Rights Institute, main author of
Foot Soldiers for Democracy

Who were the foot soldiers who stood up to such vicious violence? Who were the folks who made this movement, whose courage forced the city to negotiate and the federal government to intervene? Who were those unnamed idealists, who, in deeds rather than words, helped author King's renowned "Letter from Birmingham Jail"?…Many foot soldiers have stories yet to be told.
—Historian Robin D.G. Kelley from the introduction to
Foot Soldiers for Democracy

The Foot Soldiers of this revolution followed these leaders and through their collective effort helped usher the end to public segregation and passage of the Civil Rights Act of 1964, the cornerstone of civil rights law…The Foot Soldiers were ordinary men, women and children possessing extraordinary fortitude by marching for justice and equality within a society blinded by racism.
—City of Birmingham document calling for creation of "A monument to foot soldiers, a national design competition, for architects, artists, designers"

CONTENTS

PREFACE/CONTROVERSY

Writing a book about foot soldiers in the Birmingham civil rights movement is a daunting task, not least because historians and journalists of note have done it before. The year 2013 was fifty years after the most pivotal struggles in the city's turbulent, seemingly intractable fight over segregation. Alabama's largest city was filled with the sights and sounds of commemorations: re-created marches; tours by the busload visiting the Birmingham Civil Rights Institute (BCRI), Sixteenth Street Baptist Church, Kelly Ingram Park and other sites of important protests and confrontations; banquets; speeches; exhibitions; concerts; and, yes, pages and pages of writing—all centered on the subject of the movement.

And so, as this book began and ended, words were flowing from more and more writers about the marches, their leaders—Martin Luther King and Fred Shuttlesworth—and, most notably, inevitably and appropriately, the marchers themselves, the foot soldiers.

Just as I was starting this book, the Metro Birmingham Branch of the National Association for the Advancement of Colored People (NAACP) was starting a "Foot Soldier Finder" project, with the aim of locating more of those unknown soldiers who marched among the thousands. "Most of the foot soldiers, people who really were the boots on the ground, they don't feel that they have received the appropriate level of even respect because in their minds others benefited from their work, they benefited from their sacrifices, they benefited from their struggle," said Hezekiah Jackson, president of that NAACP branch.

Even before 2013, many have broached the subject. One of the most notable predecessors for this book is *Foot Soldiers for Democracy*, principally authored by historian Horace Huntley in conjunction with the Birmingham Civil Rights Institute's Oral History Project, which Huntley was integral in inaugurating. Other books, like Taylor Branch's *Parting the Waters* and Diane McWhorter's *Carry Me Home: Birmingham, Alabama, the Climactic Battle of the Civil Rights Revolution*, have dealt with the Birmingham movement to international acclaim. The Birmingham Historical Society has published several volumes of material on the subject, some of which I refer to herein.

Local newspapers, including the *Birmingham News*, the *Birmingham Times* and the papers for which I have worked—the now-closed *Birmingham Post-Herald* and the relatively younger weekly called *Weld* (which I currently edit)—have dealt extensively at various times with the history of civil rights in Birmingham. And so I have already had the privilege of interviewing several foot soldiers myself and editing the work of others who have written about their stories.

So it is a field crowded with entrants. And yet there is so much more to tell.

Indeed, there were so many people who risked their safety against the civic machine run largely by the infamous public safety commissioner Theophilus Eugene "Bull" Connor by participating in nonviolent sit-ins, leaflet campaigns, picketing, mass meetings, marches and other demonstrations that there are literally thousands of stories to tell. I endeavor to tell only a few of them.

In doing so, I have striven to report facts as a journalist would, as accurately as possible and certainly without any illusion that I'm the first on the scene of this story. Still, I believe that the more voices of those who were there that can be heard, the better for the completion of the story. Some of it might still never be known, however.

For one reason, as you can well imagine, some of those who participated have since died, taking their recollections and insights with them. For some, the events that unfolded here left scars, deep wounds. One man I talked to said he knew he had suffered posttraumatic stress disorder after being shot in the Vietnam War, but it wasn't until he started talking about the stress he experienced while being harassed by racists and locked up for marching in Birmingham in the years before the war that he started to heal.

In light of that, it might not be surprising that some foot soldiers don't want to talk about what they went through. For some, it's still too hard to do. There are also those who have tired of telling their stories, having recounted them for various reasons to the degree that they no longer want to—at

least right now. There were a number of people I approached about their accounts who simply did not want to talk at the time.

At least a few, upon sharing their stories publicly, have found themselves targeted by critics who either question their veracity or—and this is still an unfortunate factor among the racially challenged in Birmingham—would rather people just forget about what happened here all those years ago.

And there is a thorny issue: exploitation, or the fear of it, which has made some feel that they should be paid for their stories. A black activist in Birmingham told me—and I'm paraphrasing here—that it seems everybody profits from our stories but us. There are, of course, many historical precedents that could lead to such a conclusion—documented instances where black talent or the product of the ingenuity, artistry or craftsmanship of African Americans was essentially stolen, assumed by others as their own, leaving the actual creators behind the scenes, out of the picture, unenriched and unacknowledged.

While no foot soldier I approached came right out and said that, there was one who hinted that she wanted to be paid for her story. My suspicions were verified by others who knew her.

(I can sympathize with any who feel that way. However, my counterargument is twofold. First, as a journalist, I've never paid anyone for the privilege of telling his or her story; many people who have a story to tell want their stories told, and told with accuracy and integrity, and seem to consider that opportunity and whatever benefits of notoriety or fame that come with it to be payment enough. Second, I'm completely up front about what I'm doing: writing a book. There's no hidden agenda here, and anyone I approached was free to participate or not, knowing fully what my intentions were.)

There are other elements, relating to time, that add layers to the difficulty of telling the stories of foot soldiers in Birmingham.

There are many today who will recount in some detail what it was like to be on the front lines of the civil rights battles fought in Birmingham with passion, conviction and heartfelt expressions of what those events and their participation in them meant to them, their families and the lives they would live afterward. Most, I suspect, are completely sincere and, in the main, accurate in what they say.

"I think what happens with most of them when they come forward," Jackson said, "is they just want to be able to tell their story." Thankfully, there are some who do.

But it is good to keep in mind that memories of events from fifty years ago, no matter how profound, can fade or become clouded by age or mixed in with the

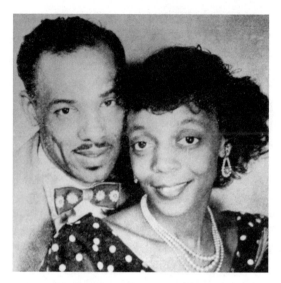

Carl and Alexinia Baldwin were foot soldiers arrested while trying to integrate public facilities in Birmingham. *Image courtesy of BCRI Archives.*

accounts related by others of events they witnessed or even participated in. Wishful thinking can cause—and has—people who actually participated in the marches to put themselves in places at times they could not have been there.

Several examples were brought to my attention, each a cautionary tale.

One prominent survivor of the Sixteenth Street Baptist Church bombing, which killed four young girls, has at times believed and stated that she was depicted in a famous photograph taken earlier in 1963 being battered by a jet of water from the cannons of the Birmingham Fire Department. In light of evidence that the girl she thought was she in the picture was someone else entirely, she backtracked on years of attestations. This led to some accusing her of lying to make herself look good.

Yet this is a woman who has become well known as an author, a minister and, more to the point, the girl who answered the telephone to get a cryptic warning from the bombers moments before dynamite shattered the church, ended four young lives and changed the course of history. Would she really need to lie about being blasted by a fire hose? I might be naïve, but in this case, I prefer to think she simply made the kind of mistake possible when one is so invested in a subject that has dominated and overshadowed much of her life and her imagination or all-too-human recollection bridges the gap.

A surplus in enthusiasm and a shortening of memory can cause people to compress the time elements of events so that they remember things as happening more in proximity to one another than actually occurred. One of my interviewees, whose account, in general, has been attested to by another, mentioned while talking to me that the last time she got out of jail for protesting was the day before the Sixteenth Street bombing on September 15, 1963. But the facts are that the protests in Birmingham that led to the arrests of thousands had occurred in April and May of that year. By

September, while racist terrorists were still planting bombs in the city against African American targets, the mass jailings in which my subject participated were long over. It is highly unlikely that she was in jail the day before the church was bombed. Was she lying? No. I'm reasonably sure that she was just momentarily compressing the details.

Myrna Carter Jackson, interviewed for this book, is very quick to show her jail record and refers often to the need to verify the histories of those who claim to be foot soldiers. She is especially critical of those who appear late on the scene. "I know that no matter how involved you were in the movement or how long you were involved, it is impossible to know everybody that was involved," she told me.

> *But I have a problem with people coming out of the woodwork—nobody knows anything about them, nobody's heard anything about them in fifty years and now they are making headlines. There is no proof. There is no documentation whatsoever that could connect them to the movement because, if we're honest with ourselves, we will realize that a lot of ministers and churches didn't allow the movement to meet there at those places. A lot of ministers would not speak out. They were afraid. A lot of people were afraid.*

Still, on the subject of who speaks the truth, there are other angles to ponder. Pulitzer Prize–winner Diane McWhorter, of the aforementioned *Carry Me Home*, also warned about how hard it is at this point to judge the truthfulness of some accounts:

> *It's difficult to know how much of some of these stories are true. At the same time, some of it may have happened, but everyone didn't see the same thing so what they didn't see—they think didn't happen. Like interviewing everyone at a party, you'll get several different views of what went on there because everyone didn't see the same thing…*
>
> *I'm not trying to be critical of people. I'm just saying that there is some type of human urge to try to… It's human nature to exaggerate, and it's too bad that now it's become this kinda squabbling about who did what rather than focusing on how many people really benefited from this. It sort of reflects the amount of, or the lack of, spoil to go around. The movement was huge, and it changed a lot of history, but a lot of people's lives, it didn't really change that much, so if that's the case, that's your asset in a way and you really want to take care of that asset. And maybe that asset is going to keep growing. I don't mean asset in a material way as much as*

in a spiritual way. And maybe the change from that incredible turning point wasn't as dramatic of a change as we'd hoped it would be. So, maybe some of the exaggeration is kind of a reflection of that as well.

Journalists often depend on the words and recollections of others to reveal what we could not have seen for ourselves, and so, with the imperfect recall of foot soldiers half a century away from the actual events, and with the added imprecise reporting of same in print and film and the countless other bits of misinformation that attach to any story of legendary merit, we do the best we can to unravel the truth and present it. That's what I've done here.

Of course, sometimes people lie. And among those who claim the status of foot soldier, there are in fact some people who are stealing fame by telling stories that are embellished or worse. And if it seems scandalous for me to report that, just understand that this is not news to the scores of actual foot soldiers who remain in Birmingham or who can be reached to tell their stories. It might be shocking to realize it, but there is some disagreement among the ranks of professed civil rights infantry.

There are several organizations in Birmingham who lay some claim to the title of foot soldier. Besides the NAACP, as mentioned earlier, there is also a Civil Rights Foot Soldiers organization in town. They don't always agree on exactly who deserves the designation "foot soldier."

"The friction goes back to revenge," suggests Terry Collins, vice-president of the NAACP in Birmingham and one of the subjects of this book.

People are envious of people who have gotten credit for the same things that they did. Some people feel like, "I did the same thing—so why am I not being honored?" I don't go around telling everybody about all of the things that I've done because people will resent me. That is the sad side of it, that someone would resent you for doing something and having the talent for doing something that needed to be done. So it was fate to a large degree. But there are also those people who will resent a person, good or bad, no matter what.

Of course, that doesn't mean the disagreements don't stem from substantive deviations from what is objectively true. But with foot soldiers, as with the movement, the truth is complicated.

It is, in case you're wondering, quite possible to document the participation of many specific individuals in the movement. The BCRI archives contain

remarkable documentation of those who participated in the struggle, including photographs taken by police officers doing surveillance on the activists. The Birmingham Public Library (BPL) Archives, the official repository of the records of the city and of Jefferson County, also preserve such important evidentiary proof as the very jail docket books where the names of King, Shuttlesworth, Ralph Abernathy and their adult followers are recorded. Based on the list provided by the BPL, for instance, the NAACP was able to publish the names of more than one thousand marchers who were seventeen or older who were arrested in 1963, some of whom were interviewed for this book.

It should be noted, however, that some of the more important demonstrators of the Birmingham movement were actually not documented in their arrests. They were schoolchildren who skipped school or left school by the thousands to add their voices to the freedom songs and their bodies to the masses that would confront the established segregation and the defender of its twisted faith, Bull Connor. Although some were booked and listed in jail records—particularly early in the period of demonstrations—as the events continued and the numbers grew, some of the children were not officially booked.

"There were many adult foot soldiers of adult age, and I thank God for all of them," Shuttlesworth once told me. "To be truthful, it had to be the children that served as the basic foot soldiers that overran the jails, and the city and the county facilities."

The Children's Crusade in May 1963 would see thousands of youngsters younger than eighteen incarcerated in the Birmingham and Jefferson County Jails, held in 4-H club pens at the Alabama State Fairgrounds (also known as Fair Park) and in juvenile detention facilities. Many of the children—whose numbers, by some accounts, included kids as young as six—were never recorded by name in any official record.

"We discovered," Hezekiah Jackson said, "that people who were arrested and carried to the Fairgrounds, that there was no documentation for their arrest. We also discovered that if people were identified as juveniles, they were carried to juvenile detention without documentation of their arrest. They were just herded like cattle—put onto school buses, put on church buses and taken to the facility to wait for somebody to come for them."

Even in the absence of official police records, of course, there is no doubt that the children were there, battered by the force of water cannons; menaced by snarling police dogs; photographed and filmed by

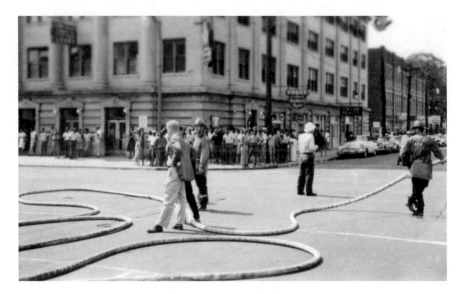

Bull Connor turned the public safety apparatus of an entire city into a mechanism of enforcing an oppressive system that denied equal rights to people of color. *Image courtesy of BCRI Archives.*

local, national and international media; crammed into paddy wagons and detention facilities meant to hold far fewer people; held for days; and, in the case of more than one thousand students from Birmingham City Schools, expelled because of it.

Some of those former child soldiers are among those interviewed for this book. Each person I interviewed had a story to tell unique to his or her experience. In the space and time allotted for this project, there was no way to adequately provide the perspectives of every one of the thousands who were a part of the movement. But the stories told in these pages offer many interesting details about what it was like to wage war with an entrenched enemy determined to maintain separation of the races and white supremacy in Birmingham.

So when you read the accounts in this book, know that it is just as certain that you are hardly reading the last word on the subject of civil rights in Birmingham as it is that the words you are reading are worth your consideration.

This book, therefore, for all its good intentions, will serve merely as a piece of the record, not as a monument, of what the foot soldiers did. There are, in Birmingham and in other places, more fitting monuments dedicated to them. One, erected in May 1995 in Kelly Ingram Park

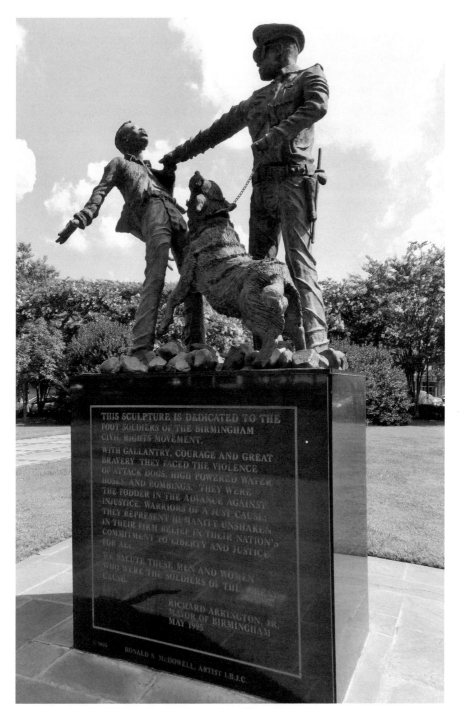

A tribute to foot soldiers in the Birmingham movement is on the plaque and in the scene depicted in this sculpture at Kelly Ingram Park.

under the auspices of Richard Arrington, Birmingham's first black mayor, contains these words:

> *This sculpture is dedicated to the Foot Soldiers of the Birmingham Civil Rights Movement. With gallantry, courage and great bravery they faced the violence of attack dogs, high powered water hoses, and bombings. They were the fodder in the advance against injustice, warriors of a just cause; they represent humanity unshaken in their firm belief in their nation's commitment to liberty and justice for all. We salute these men and women who were the soldiers in this great cause.*

ACKNOWLEDGEMENTS

I would like to thank The History Press for inviting me to tell these stories and for putting up with how long it took to do it.

This book could not have been done without the unflagging support of the Birmingham Civil Rights Institute, whose archivist, Laura Anderson, made pictures and documents available, pointed me toward sources and gave encouragement above and beyond the call.

My thanks also go to the Metro Birmingham Branch of the National Association for the Advancement of Colored People for greatly aiding my search for the unsung, which coincided with its "Foot Soldier Finder" project.

I owe a terrific debt of gratitude to Diane McWhorter, who, despite her celebrated status and having talked to me only twice before, was willing to share her knowledge, which I hope I put to good, if limited, use.

Also I would like to thank an old friend and colleague, writer Majella Hamilton, who took time out at the eleventh hour to look over the edits for me.

I'm grateful to *Weld*, as well, particularly for giving me the excuse to get reacquainted with Leroy Stover, whose experience helps round out the narratives of the foot soldiers who made his career possible.

Thanks to the Birmingham Public Library Archives, which, as the city's official repository of documents, shared some images for this publication.

Finally, and most importantly, I would like to thank my wife, Adetrice, who not only gave me much-needed moral support, love and sympathy when I needed it, but who also, while taking better care of me than I deserve, as she

ACKNOWLEDGEMENTS

always does, took the time out to help transcribe some of the interviews and format the biggest single piece of copy I have ever turned in. Without her, this really wouldn't have been possible.

INTRODUCTION/CONTEXT

Students of civil rights history already know much about Birmingham and the role of its foot soldiers in the struggle against segregation and official public racism. As I write these words, the city is in the middle of a week dedicated to commemorating the events of 1963, fifty years past.

And yet, there is ample evidence that there are still many who live in this town, perhaps blocks away from where history was made—or maybe even closer—who still are unaware of exactly what took place. There are students who have never been, for instance, to the Birmingham Civil Rights Institute, the most prominent structure in the community dedicated to teaching the lessons of civil and human rights. Indeed, the BCRI, whose assistance was invaluable in producing this book (and other articles and stories written by me and many others), succeeds in educating thousands of visitors to Birmingham each year and multiples of that this year, when the entire city's tourism engine is tuned to civil rights. And yet, for one reason or another, many people who live in Birmingham remain less than fully aware of the city's important historical significance.

Just days before commemorating the fiftieth anniversary of the September 15, 1963 bombing of the Sixteenth Street Baptist Church, Birmingham mayor William Bell told me in an interview that "new generations don't fully understand the impact of what was happening then. They don't have an appreciation for signs over a water fountain that says, 'Colored,' or 'White only.' They can't have an appreciation of riding public transportation but being required to sit in a certain location, the idea that you're restricted in your travel, that you can't ride a Greyhound bus with other races. Well," he

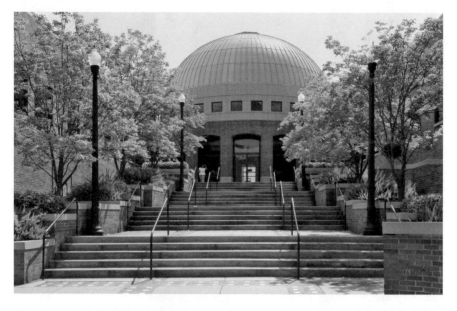

The Birmingham Civil Rights Institute is an educational organization dedicated to human rights in Birmingham and around the world.

said, "that's gone. But it's gone because of the sacrifices that were made. It's gone because people said, 'We can't live like that.'"

Just as many are less familiar than they could be with the era of civil rights, many are unaware that they are walking past foot soldiers in Birmingham every day. The civil rights movement was, after all, a struggle waged not by militarily trained infantry armed with guns, grenades and bayonets, but by an army of foot soldiers trained by ministers to be nonviolent in the face of provocation, armed with steely determination, their faith and their outrage over injustice. Today, many who were foot soldiers in an extraordinary time have returned to very ordinary lives, having jobs, raising families, living and dying as regular folks and certainly not as local celebrities. Unless they have a reason to talk about what they went through in the 1960s or earlier, they might not do so.

So, before beginning to tell the stories that individual foot soldiers have to tell, let's start with why they have stories at all, why they felt compelled to do what they did. If you already know the context of the civil rights era—with which I will deal in very brief, elementary detail—feel free to skip ahead. The remainder of this chapter is for those less familiar.

It is no secret that American history contains more than a little oppression or that much of that oppression derives from notions of white supremacy, which

The Birmingham movement put passive resistance in the path of Bull Connor's decidedly violent police and fire department forces, as markers around the city now note.

The iron statue of the Roman god Vulcan overlooks Birmingham, perhaps a fitting symbol of the iron rule of oppression that once reigned and the iron will it took to overcome it.

some believed was a divine right. Slavery of Africans was present from the founding of the nation, and even after it ended legally, there was a white power structure that resisted by force, by law and by every means possible the idea that black people could ever become equal citizens of the United States.

The Southern states, the cradle of the Confederacy, fought racial equality with particular fervor and longevity. Alabama—the Heart of Dixie—was as entrenched as any place in the country when it came to enforcing laws designed to keep blacks and whites on separate social planes. And Birmingham, which Martin Luther King famously called "the most thoroughly segregated city in America," was singular in its iron-fisted enforcement of racial separation.

From the time of post–Civil War Reconstruction onward, Jim Crow laws and the traditions and customs they propped up made it illegal for blacks and whites to socialize together; required that blacks sit behind whites on

conveyances of public transportation like buses; segregated blacks to the balconies and mezzanines in public theaters and courtrooms; demanded that African Americans drink out of water fountains mounted low on the wall in clear sight of the more ergonomic and sanitary water fountains labeled "Whites only"; and mandated that young "colored" children attend schools with only their "own kind," schools typically less well funded than those for white children and often supplied with a surfeit of books and those out of date, used and discarded by the schools they were not allowed to attend.

Children growing up in the Birmingham of that era were discouraged from close contact with peers of another race and worse. Violence could easily ensue for violating the social norms, even for children. For adult blacks, consigned to subservient roles and menial jobs, made to endure daily common snubs and racial slurs, seemingly never to experience a level playing field when it came to where they could live, where and how they could work, how much money they could earn or even the protection of the law, Birmingham was far less of a "Magic City" than its nickname claimed. Until 1966, the Birmingham Police Department was all white, and many of its officers, if not actually members of the Klan (and many were), were at the very least under its influence. Headed by Bull Connor, the police could be nearly as menacing to black Birminghamians as their white-robed brethren.

Although many whites were perfectly content with the status quo of a separate and unequal society in Birmingham—some even deluded themselves into believing that blacks were equally satisfied with the way things were—protests arose over the discrimination endemic to the community. In 1956, Fred Shuttlesworth, the fiery, seemingly fearless pastor of the Bethel Baptist Church in north Birmingham, started an organization designed to replace the National Association for the Advancement of Colored People, which had been essentially banned in Alabama. Called the Alabama Christian Movement for Human Rights (ACMHR), Shuttlesworth's organization began holding mass meetings in black churches throughout the city, galvanizing support for efforts to desegregate Birmingham and stop discrimination. Shuttlesworth became the target of attacks by racists, who tried to kill him by dynamite bombing his house, which was the parsonage attached to the church. There were other bomb attacks on other black citizens, all in an effort to stop the movement toward integration and civil rights. Shuttlesworth pressed on, undeterred. Although he had the support of many churches, there were many others that didn't get involved or that actually opposed his tactics.

"He had a smaller, working-class church. He was shunned by the so-called big preachers, and partly, it's kind of understandable...As someone

put it to me, there were some preachers who weren't worried about their churches getting blown up and that was his way of saying—look, everybody was legitimately scared of getting involved here, and Shuttlesworth was the perfect cautionary example of what could happen if you stuck your neck out," says historian and author Diane McWhorter.

So it was not surprising that other churches were not involved, but what really surprised me was the extent to which Shuttlesworth was undermined by fellow preachers. His thing was always, "Look, I'm not really asking you to go with me here. I'm just asking that you not oppose me."

He certainly understood why people would have issues with direct action and getting involved in that. Shuttlesworth was controversial. He was autocratic and wasn't running a beautiful democracy, as he would say, but he got things done. In a way, I sometimes think that the criticism of Shuttlesworth was a way that people were able to duck the call and kind of like put it off on him. But on the other hand, he really was kind of frighteningly courageous. There are just not that many people like that alive. The further I get away from that story, the more miraculous it seems to me that he survived.

And it was in Shuttlesworth's organization that the foot soldiers became so important.

"One thing about Birmingham that's key is that it was one of the few places that really did have foot soldiers because, certainly within the memberships

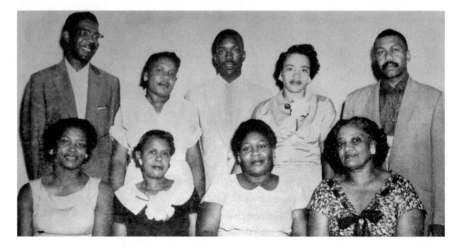

These were among the early members of the Alabama Christian Movement for Human Rights. *Image courtesy of BCRI Archives.*

When the NAACP was effectively outlawed in Alabama, the ACMHR sprang up to take its place. *Image courtesy of BCRI Archives.*

of SCLC, Shuttlesworth was the only one who sustained a movement over the years," McWhorter told me.

> *Sometimes you would have movements rise up and disappear, like the Montgomery Improvement Association in Montgomery or like the bus boycott in Tallahassee, Florida—they never were sustained. But I remember in some of the early accounts of the movement Shuttlesworth was sort of criticized for having such a small membership in the Alabama Christian Movement, compared to what the black population as a whole was. But the way I look at it is—Wow, he is the only person who had anybody meeting every week for all those years…The fact that this was an ongoing mass movement made it exceptional in the movement and in history.*

After several years, however, the forward progress of the movement in Birmingham seemed to stall. Not everyone in the black community, or in the black churches, was onboard with the confrontational style Shuttlesworth manifested. To some degree, there were divisions along economic lines.

"Much of the grass-roots membership of the movement was sort of shunned by the so-called classes of the black middle class and the professional class," notes McWhorter. "They shunned the movement because they were people who were working folks."

Shuttlesworth invited King and his Southern Christian Leadership Conference (SCLC) to Birmingham to help.

Together, Shuttlesworth, King and other ministers, including Wyatt Tee Walker, Ralph David Abernathy, Andrew Young, James Bevel and others,

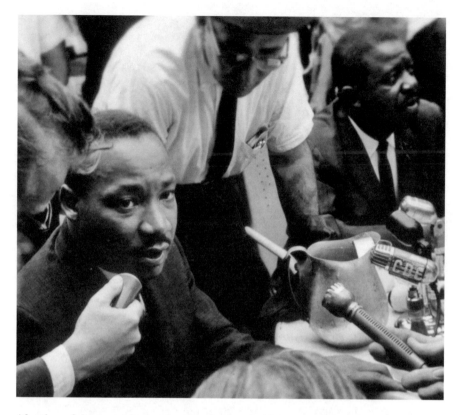

After days of demonstrations and arrests that wreaked havoc on business and drew international attention, King, Abernathy and Shuttlesworth (not pictured) announced a truce with the city. *Image courtesy of BCRI Archives.*

devised a plan to cripple the engines of segregation in Birmingham. Project C (for Confrontation) would bring the masses out of the churches and into the streets in campaigns targeted toward the Easter season of April and May.

Those campaigns of nonviolent resistance, calculated to make Connor show his true colors and invite the scrutiny of national and international leaders and journalists, would include peaceful marching and singing, picketing, attempting to desegregate lunch counters by having blacks sit in seats reserved normally for whites and attempts to desegregate white churches and schools. That's where the foot soldiers came in, adding mass to the movement. "They were very critical, and they were definitely critical by the time '63 rolled around, to prepare for Project X at the time, before it became Project C," McWhorter says. "They ended up having to turn to children anyway because the adult so-called foot soldiers couldn't really support being at mass demonstrations. But it

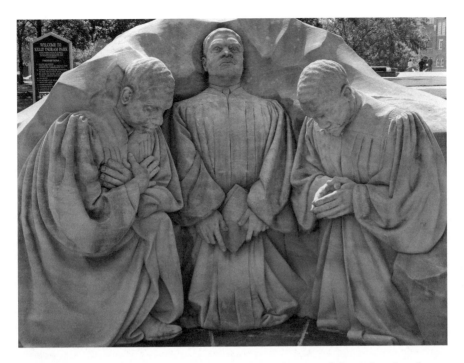

This sculpture of kneeling ministers is based on an actual event and dramatizes the role black preachers played in the anti-segregation movement.

was critical to getting the campaign started here, to have those early volunteers who were willing to march and go to jail."

As reported in *Minutes: Central Committee 1963*, Shuttlesworth spoke to the point of the campaign in a statement he made on April 8, 1963:

> *Since Wednesday, April 3, over 100 persons have been arrested for peacefully demonstrating against segregation practices in the stores of downtown Birmingham. The possibility is very real that many others, including citizens from other parts of the state and the nation will make their witness against the unjust system. The Negro community had made it perfectly clear that they will submit to arrest and jailing to demonstrate that they will no longer endure the laws and custom of segregation, brutal treatment by the police and injustice in the courts.*

Indeed, the plan evolved in the face of staunch resistance and many arrests, including those of King and Shuttlesworth. In a new stratagem hatched primarily by Bevel, children, many of whom were already attending

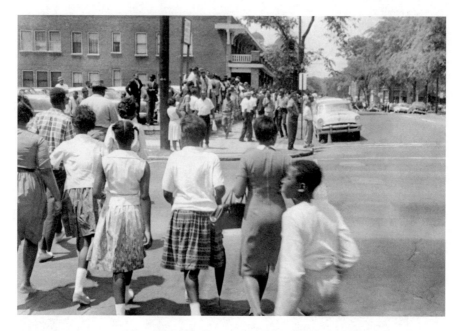

It took the masses to bring to bear the amount of pressure needed to force an end to segregation in Birmingham. And the masses included hundreds of schoolkids. *Image courtesy of the Birmingham Public Library Archives.*

the mass meetings with their parents, would be invited to participate in the marches and protests.

The Children's Crusade placed scores of kids—teenagers, mainly, but younger ones as well—squarely in the spotlight. They left their schools for several days starting on May 2, 1963, walked to the Sixteenth Street Baptist Church, got organized and then flooded the streets of Birmingham, their young voices joined in spiritual freedom songs. They marched toward downtown targets, including department stores and city hall, and they were met by Connor, with his policemen and their dogs and his firemen and their powerful water cannons. Children were therefore among those thousands who eventually were arrested as foot soldiers in the movement.

As the Children's Crusade came to a close, the movement's leaders were busily negotiating a truce that would end the demonstrations in exchange for accommodations ending public segregation in Birmingham. In a short time, Connor and the rest of the city commission was gone, replaced by a mayor-council form of government. Birmingham was changing.

But the story of how those changes were wrested from the clenched fist of the segregation machine is the story of Birmingham's foot soldiers.

FRED SHUTTLESWORTH

I f there is one name you will read more than any other in this book, it
will be that of Fred Lee Shuttlesworth. He figures into the story of every
individual foot soldier. Before Martin Luther King came to Birmingham—at
Shuttlesworth's urging—the pastor of Bethel Baptist Church in Collegeville
was undisputed as the leader of the civil rights movement in the city. As the
years of the local struggle wore on, Shuttlesworth was regarded as if he were
a general—if the rank and file of the mass meetings and protest actions were
the troops.

But like many a military general, Shuttlesworth was, at first, a foot soldier
in this war he was fighting. And as the resistance movement continued,
he was hardly an armchair general. As Shuttlesworth biographer Andrew
M. Manis said, speaking at the Sixteenth Street Baptist Church in 1998,
"The fire hoses of 1963, which never unloaded a drop of water on King or
Abernathy, slammed Shuttlesworth against the side of this church building
and bruised his ribs. But they never extinguished 'the fire you can't put out.'"

Shuttlesworth, who died on October 5, 2011, in Birmingham, is an icon
of the movement in the city. He lived to see a statue of himself erected
in 1992 outside the Birmingham Civil Rights Institute. A street in the city,
F.L. Shuttlesworth Drive, is named after him, as is Birmingham's airport:
Shuttlesworth International. President Bill Clinton awarded him the
Presidential Citizens Medal in 2001.

His particularly fiery activism is well documented in many books and
some films on the movement, and yet, outside Birmingham and beyond

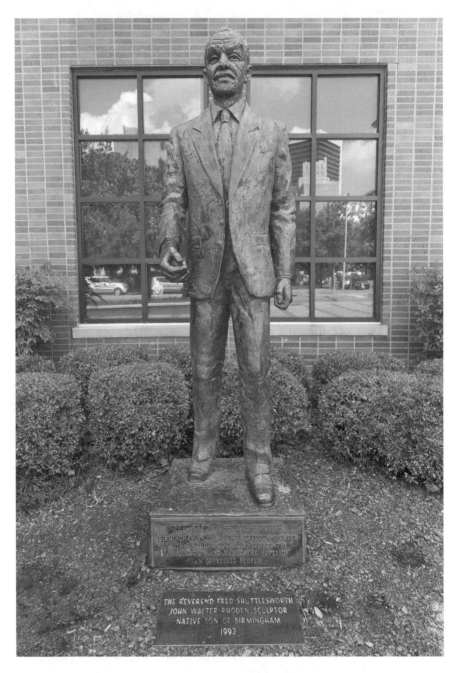

A statue of Fred Shuttlesworth, the undisputed leader of the civil rights movement in Birmingham, greets visitors to the Birmingham Civil Rights Institute.

those particularly informed about the history of the southern civil rights era, it is not clear how well people in general know who Shuttlesworth was. In many tellings of the story of the southern movement, King's name is mentioned above and more often than other ministers who supported the cause—and naturally so.

Yet the Birmingham movement, and the civil rights movement as a whole, owes Shuttlesworth what might be an incalculable debt.

By the time Shuttlesworth appeared on the scene, Birmingham seemed unwilling to budge on most issues related to the civil rights of black people.

"There was a lot of apathy and resignation in the community," said Diane McWhorter. "People had just lost any hope that things could be any different. The black middle class had accommodated themselves to it in a certain way, being able to prosper within limits, even though they suffered the same humiliations that every black person did when it came to public accommodations and stuff like that.

"Someone I quoted said Shuttlesworth just had an absolute sense of what was right, and he was uncompromising in pursuing that," McWhorter continued.

> *He was just very clear about what he wanted. King was more of a, like a Hamlet when speaking. He was more willing to finesse things, but Shuttlesworth didn't really have any finesse. He was just really sort of a ramrod.*
>
> *We look back on it now, and we can see that he was right, but if you put yourself in the place of people of the time and you can see why those who followed him were pretty exceptional. When you say "foot soldiers" it sort of implies that there were a huge number of people who were engaged at some meaningful level for a long time. But there were just a few hundred, really, if that, from 1956 when the movement was founded. But then, of course, you get thousands of foot soldiers once the kids get involved.*

Where did Shuttlesworth come from? How did he first get involved?

In the introduction of the book *Minutes: Central Committee 1963*, Birmingham Historical Society director Marjorie White notes the significant roles played by Shuttlesworth, who was secretary of King's Southern Christian Leadership Conference (SCLC), as well as head of the Alabama Christian Movement for Human Rights (ACMHR). "Through national speaking engagements, a regular column in the *Pittsburg Courier*, and his Birmingham work, Shuttlesworth was known across the country as 'the South's fearless

freedom fighter.' Historians acknowledge Shuttlesworth's ACMHR as the strongest local civil rights movement," White wrote.

Another one of White's books (edited with Manis), *Birmingham Revolutionaries: The Reverend Fred Shuttlesworth and the Alabama Christian Movement for Human Rights*, recounts a lecture given in 1998 by sociologist Aldon D. Morris at the Sixteenth Street Baptist Church. The symposium had been organized by the Birmingham Historical Society, and Shuttlesworth's role in the history of the civil rights movement was front and center in all the talks given that day. Shuttlesworth himself was one of the speakers.

Morris in particular said this about Shuttlesworth, whom he acknowledged "was the unrivaled leader" of the Birmingham movement:

> *A leader sets the tone of a movement. Leadership is responsible for a movement's vision and character...It is well documented that Birmingham's white power structure developed and maintained one of the most vicious and formidable systems of racial segregation that existed anywhere in the South...Fred Shuttlesworth and the black masses who followed him constituted that black and crazy force that stepped boldly into the belly of the beast...*
>
> *Fred Shuttlesworth conquered that fear of death. For him, the destruction of racial segregation became more important than his own life.*

Others have written in more detail about Shuttlesworth's history than I will here. But knowing a little about him might help put him in context.

Shuttlesworth was born in Mount Meigs, in Montgomery County, in 1922 but was raised near Birmingham in the then-rural area of Jefferson County called Oxmoor. He attended both Wenonah High and Rosedale High School, an all-black county school with students in grades one through twelve. Graduating in 1940, he was arrested for operating a still but sentenced to two years' probation, according to some sources.

During World War II, Shuttlesworth worked as a truck driver at an air force base in Mobile. Believing he had been called by God to the ministry, he enrolled in a south Alabama Bible college, then Selma University and finally Alabama State College, from which he graduated in 1952.

He was the pastor at the First Baptist Church in Selma before moving back to Birmingham, where he took over leadership of the Bethel Baptist Church in 1953.

He became involved in the civil rights movement through voter registration activities of the National Association for the Advancement of Colored

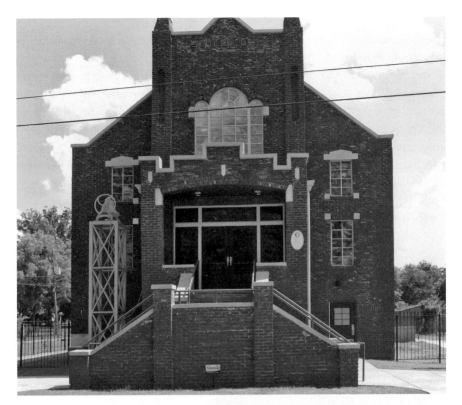

Above: Historic Bethel Baptist Church, 2013. This church, where activist minister Fred Shuttlesworth was pastor, was bombed by Klansmen.

Right: Today in Birmingham, markers like this identify the churches where mass meetings were held to organize the civil rights movement.

People and, early on, became a proponent of the City of Birmingham hiring black police officers.

In 1956, he went with attorney Arthur Shores to Tuscaloosa to help enroll Autherine Lucy as the first black student at the University of Alabama. Later that year, when the NAACP was essentially barred from operating in Alabama by a court decree, Shuttlesworth formed the ACMHR and continued the fight. The *Birmingham News* reported the day after ACMHR was formed that Shuttlesworth declared his defiance to organizations such as the White Citizens Council, formed to offer political cover to the Klan:

> *The Citizens Councils won't like this. But then, I don't like a lot of things they do…Our citizens are reactive under the dismal yoke of segregation…These are days when men would like to kill hope, when men in Mississippi can be declared "not guilty" (of murder), when men can be shot down on the steps of the courthouse. These are dark days. But hope is not dead. Hope is alive here tonight.*

Still later, in 1956, after the U.S. Supreme Court declared segregation illegal on Montgomery buses—a result of the bus boycott—Shuttlesworth announced his intention to try to desegregate transit in Birmingham.

On Christmas night 1956, Shuttlesworth's house was bombed. He survived. A marker that stands today outside the surviving historic Bethel Baptist Church captures his determination: "When a dynamite blast blew the roof off his parsonage, he emerged and told a policeman, 'Tell your Klan brothers that if God could save me through this, they'll have to come up with something better. So the fight's on.'"

He would later tell me in an interview for the *Birmingham Post-Herald* that the bombing "took all the fear from me. It committed me to spending the rest of my life—since I was not destroyed then—to live as a challenge to segregation. A living, continuing, challenge."

From then on, if he had not been convinced before, Shuttlesworth viewed it as God's mission for him to fight against racial segregation in Birmingham. "I tried to get killed in Birmingham…but God didn't want me," he said the day before a statue in his honor was dedicated at the Birmingham Civil Rights Institute. "When that bomb went off, God took all the fear from me. What was there to fear when you don't fear death? I wasn't trying to be safe. I was trying to destroy the thing that was keeping people from being safe."

Shortly after the bombing—the very next day—he led more than three hundred black protestors to board the Birmingham buses in violation of

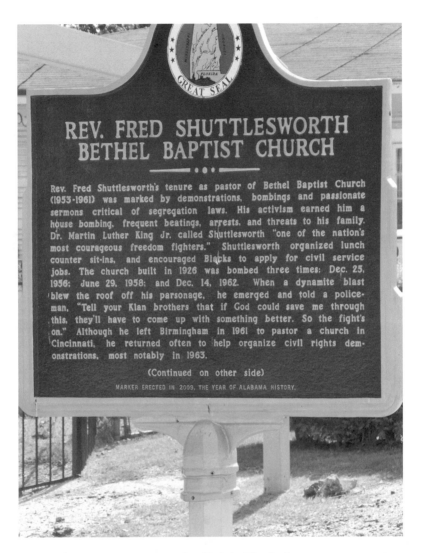

At the church where Shuttlesworth rallied the Birmingham movement members, a historic marker pays tribute to his defiance in the face of Klan and police opposition.

the segregation ordinances. When more than twenty of them were arrested, Shuttlesworth filed suit.

In 1957, Shuttlesworth helped King and others create the SCLC, where he was secretary for a dozen years. Later that year, Shuttlesworth and his wife, Ruby, used the whites-only waiting room at Birmingham's Terminal Station, challenging the segregated facilities that famously stood behind a

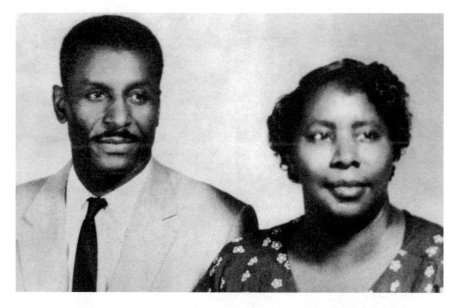

Fred and Ruby Shuttlesworth, on the frontlines of the Birmingham civil rights movement, were assaulted while trying to integrate city schools. *Image courtesy of BCRI Archives.*

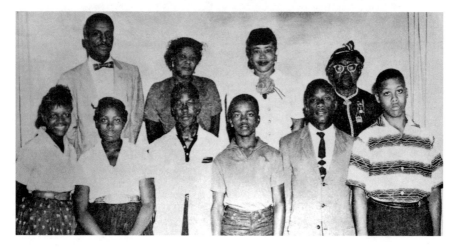

Fred Shuttlesworth, his daughters and other parents and students fought in the courts to desegregate Birmingham's public schools. *Image courtesy of BCRI Archives.*

monumental sign that read, "Welcome to Birmingham, The Magic City." They were arrested.

When he attempted to enroll two of his daughters in Birmingham's Phillips High School in September 1957, he was beaten by thugs armed with

bats, bicycle chains and other weapons. A newsreel photographer's image, published on the front page of the *Birmingham News*, captured the gang attack. Shuttlesworth, being treated for his injuries at University Hospital, told a reporter he would push for integrating Phillips, "whether they kill us or not."

Shuttlesworth and the ACMHR filed lawsuits and organized boycotts, marches, sit-ins and pickets. In 1957, the same year Shuttlesworth was beaten while trying to enroll his daughters at Phillips High, his associate James Armstrong, a barber and foot soldier in his own right, filed suit against the Birmingham Board of Education to force the schools to allow his children to attend the all-white Graymont Elementary School. Shuttlesworth accompanied him and his children to the school in September 1963, when, after winning their suit in federal court, the Armstrongs became the first black students enrolled after the formal end of segregation in the city system.

Bethel was bombed again in 1958, although volunteer guards moved some of the explosives away from the building. Had it all gone off, it would have destroyed the church and possibly caused injuries.

"Danger and death forever stalked our lives," Shuttlesworth wrote in the preface to another of White's books, *A Walk to Freedom: The Reverend Fred Shuttlesworth and the Alabama Christian Movement for Human Rights, 1956 to 1964.* Shuttlesworth recounted an incident demonstrating the degree of vigilance his organization had to maintain in a city where Klan bombings were a regular occurrence:

> *Most times I was driven by guards and Movement people to rallies and other places. But one night, in the darkest and most menacing days of 1958–60, I drove my own car and parked it beside Rev. Abraham Woods' church on the Southside, with the guards being outside for every Movement meeting. Upon dismissal that night, I got into my car with the door open and put the key in the switch to start it.*
>
> *Suddenly, abruptly, and with rough force, I was grabbed by my neck and shoulders and jerked from the car! Wondering if the Klan had suddenly overcome the guards, I looked up into the face of Will "John L. Lewis" Hall. He shoved me quickly into another guard's arms, immediately got into my car, turned the key in the switch and started the car.*
>
> *"John," I said to him, "What is the difference in my starting the car and your starting it?" Without hesitation he said, "You got to stay alive and lead us to our freedom! If I get killed, that's all right; I'm a nobody; but if you get killed now, who will lead us to freedom?"…In my heart that night I felt and fully knew the desire and need of people to be free.*

The Birmingham movement sought to negatively impact the economy of segregated facilities in downtown to force owners to treat blacks the same as whites. *Image courtesy of BCRI Archives.*

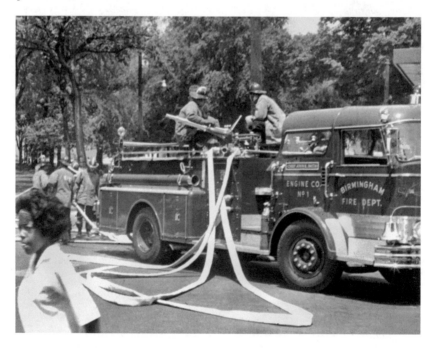

Birmingham Fire Department water cannons became a part of public safety commissioner Bull Connor's ill-fated attempt to subdue demonstrators. *Image courtesy of the Birmingham Public Library Archives.*

Even as Shuttlesworth and his allies held mass meetings at various churches throughout the city, public safety commissioner Eugene "Bull" Connor's detectives were assigned to sit in and report what was being said. At times, the Birmingham Fire Department—which Connor also used as a weapon against the civil rights movement—harassed the meetings with blaring sirens and, in at least one occasion, rushed in as if to extinguish a fire.

The fire was pure fiction. But the danger from Connor and his men was quite real. "If the North keeps trying to cram this thing (integration) down our throats, there's going to be bloodshed," Connor told *Time* magazine in 1958. Although Connor was wrong—at the top of his voice—in the naïve belief that southern blacks could be agitated only from the outside, from "the North," he was right about one thing: there would be bloodshed in Birmingham before segregation could be quashed.

In 1961, Freedom Riders, some actually from the North, were attacked in Anniston, northeast of Birmingham, where segregationists firebombed their bus. And later, in Birmingham, Connor's police officers essentially stepped aside for Freedom Riders to be attacked. As I wrote in a 2012 *Weld* story about how a former *Birmingham Post-Herald* colleague had captured a critical image of the assault on film (just before being attacked himself):

> *A mob of unrobed Klansmen wielding baseball bats, and lead and iron pipes had convened at the station awaiting a bus transporting black and white Freedom Riders headed to Birmingham to protest segregation. A different Greyhound busload of Freedom Riders had already been attacked in Anniston earlier in the day, the riders assaulted by a gang of Klansmen, and the bus burned by a firebomb hurled by one of the attackers.*
>
> *Birmingham Police, aware of the impending siege on the depot, stayed away from the Trailways station. According to well-documented accounts, the police implicitly granted the Klan 15 minutes to do whatever violence they wanted to the Freedom Riders. In fact, the civil rights protesters had already been brutally attacked by Klansmen riding the same bus, so they had been bloodied and wounded before they ever disembarked in Birmingham.*

But after those violent events, the wounded turned to Shuttlesworth for assistance. As the primary contact person for the Freedom Riders, Shuttlesworth sent people to Anniston to rescue the stranded demonstrators there, and when victims of the Birmingham assault came to him, bloody and injured, his family and members of his church bandaged their wounds and put them up. He was arrested for that as well, but that didn't stop

Shuttlesworth and the ACMHR from helping demonstrators determined to continue the Freedom Rides.

In that same year, Shuttlesworth accepted the pastorate at Cincinnati's Revelation Baptist Church; for the remainder of the Birmingham movement, he commuted back to Alabama to oversee desegregation efforts.

It was Shuttlesworth who made the mass movement against segregation the juggernaut it became. He gave the credit to God, but he also remembered the foot soldiers. In "A Walk to Freedom," he wrote, "Who deserve to be honored more than the unheralded black men and women—and especially the courageous young black school children, without whom the battle would not have been won—on the segregated battlefield of Birmingham?"

IRA SIMS

I ra Sims, sixty-six, grew up in the Powderly area of southwest Birmingham, where he eventually went to Wenonah High School. He was one of many young people in the 1960s who got involved in the movement, despite the wishes of his parents that he stay out of trouble. He represents that segment of foot soldiers who participated in civil rights activities for a time and then moved on with life, encountering and resisting discrimination in the years to come primarily in their personal lives, more as individuals and less as part of a concentrated movement. Here, Sims talks about his time as a foot soldier in 1963.

Ira Sims got involved in the Birmingham civil rights movement because he could tell that life in his city was anything but normal. He could see it, especially on those occasions when he would visit other places. "Whenever we would go out of town, I could see, something is wrong down here. The way they had everything set up. You'd go into those department stores, and they would always have the big luxury counters for the whites. And they'd always have a little counter for the blacks in those stores, but it was always back in the corner or in the basement or something like that," he says.

> One thing I never did like—they used to have the big old water fountain there. The big pretty one had "white" across it, and they would always have one, a small one, that had "colored" wrote across it. I said, "Something ain't right here." When I was a little boy, I used to always say that.

Even when we caught the buses, and stuff…We had a good bus system.
It was way better then than what they've got now. But you always had to
sit in the back. It was the idea of sitting in the back.

He remembers how the drivers would move the signs if more white passengers boarded than there were seats in the white section: "If there ain't too many white folks sitting in there, you could move the signs. One side had 'colored' on it and the other side had 'white' on it."

Constantly facing the fact that his status was unequal in his hometown, Sims was primed to get involved by the time he reached his teenage years:

I was in the tenth grade, and they usually had some mass meetings around
in Powderly, St. Johns, West End Hill and First Baptist Powderly.
Preachers would come out to the churches and stuff. Later on, we started
going downtown—Sixteenth Street Baptist Church. And they used to have
the meetings and stuff in the basement. Old Martin Luther King, old
Andrew Young, Abernathy—all the top folks. They used to come down
there and make a speech. They would come and speak to you before they put
you on different assignments.

His first involvement came in the sit-in demonstrations, Sims recalls.

The first time I went down there, they would carry us around to those
restaurants around down in Birmingham, and we would sit up at the
counters and stuff.
It was one incident I never will forget. We were sitting in one of them
counters, and there come Bull Connor, came in the door, had two big old
fellows around him. And he looked in there at everybody sitting in there,
at everybody sitting at the little lunch counter. And he was short but mean.
Looked like a little bulldog.
And he said, "Let's go and get the dogs." That's what he said, and he
walked out the door. But he never did come back in there.
Later on, there was a little old lady—I never will forget this—a fellow
was sitting at the lunch counter, and she got a cup of water and she just
threw the water on him.

Sims says he never knew his fellow demonstrator, who was just one of the kids he met up with at the church. "The only people you really got to know were some of those who came from right here in your community."

Not deterred by the hostility he witnessed, Sims continued working for the movement:

The first time I went to jail was [for] *demonstrating in front of Sears and Roebuck on Second Avenue. I had the signs up, walking around, and there come the police, and they put all of us in the car and all the juveniles went to the juvenile detention center. I was in there two or three days. Then the lawyers came. There were two black lawyers. One of them was Arthur Shores, and* [the other was Orzell] *Billingsley.*

When they held us in that little courtroom down there, both of them were sitting there...Back then, man, you weren't used to seeing—unless they were preachers or something—black men sitting up there with their suits on. They were something to see at that particular time.

For his first arrest, Sims was fined and released:

Then the second time, we met over here on the Southside. It was a church on the Southside...They [civil rights organizers] *had a little bus. They had all of us on a bus, and they carried us under the viaduct, First Avenue North...When we got off the bus, they were standing there giving us signs and stuff.*

The protestors began demonstrating, peacefully carrying their signs, until the Birmingham Police came "and got everybody," Sims remembers. "This time we went to the county jail. We were in there for a few days." Being jailed for the protests, however, was not troubling. "It was all part of the process. When you went down there, you know you're going to jail."

One reason he was so willing to get involved in the movement despite the risk of arrest was that he had teachers who, at the risk of their jobs, would talk to students about civil rights:

It was one teacher I had, Mr. Harper. He used to come around and tell you certain little things—"I appreciate what you're doing"—stuff like that. He would know you had been down there [protesting]. *They were supportive teachers, but they just couldn't get involved in it. Because it was their job. Back then, folks would get rid of you quick.*

In fact, while the masses of foot soldiers eventually became thousands strong, they were nevertheless just a fraction of the black community. Most

Ira Sims was a child soldier in the Birmingham civil rights movement and went on to fight for his country in Vietnam.

black residents, although chafing under the restrictions of segregated society, did not get directly involved in the movement. "They were scared," Sims says. "You mostly had the same ones going over and over."

His parents, on the other hand, did not want young Ira to get involved. "They didn't want you to go down there," he says. "You had to ease away. You had to get away from them. It was the same way for the rest of them in that neighborhood. They were scared. You could see it, in a sense," Sims said. "But it was time to break that. Take a chance. They would have kept on doing it, if you had let them do it.

"It always pays to let folks know what went on because you have some folks who think all this stuff was given to them. That's why you got some that walk around like they don't give a damn because they never have realized what went on during that period of time."

FLORETTA SCRUGGS TYSON

(FROM THE BCRI ARCHIVES
ORAL HISTORY PROJECT)

A s I mentioned earlier, mine is certainly not the first book on the subject of foot soldiers in Birmingham. Historian Horace Huntley wrote a book on the subject based largely on the interviews he conducted with former demonstrators for the Birmingham Civil Rights Institute's Oral History Project. Although he selected a number of interviews for his book, there were quite a few left on the table. Many of those people have interesting stories to tell. The account of Floretta Scruggs Tyson, who interviewed with Huntley on May 5, 1995, is a typical example. She grew up in Birmingham's Titusville community and attended Ullman High. Like a lot of her fellow Ullman students, she frequented the mass meetings held at different churches on Monday nights. She tells about getting ready for the consequences of defying the system:

> *Well, I was kind of nervous leaving home because I really didn't think I was going to jail, but I was getting prepared to. Because in the movement they were teaching us the nonviolent act and what to do in case we went to jail. I just don't believe we were going to jail because it's too many of us. It never really dawned on me that I was going to jail, until I went...*
>
> *I took things out of the house like underwear, toothbrush, toothpaste in case I went to jail. And I was doing all of these things without my parents knowing that I was doing them. Because I knew she wouldn't like it, so I did it anyway. So I went on like I was going to school. And before I got to school, I was met by a group of people that said, "I know you're*

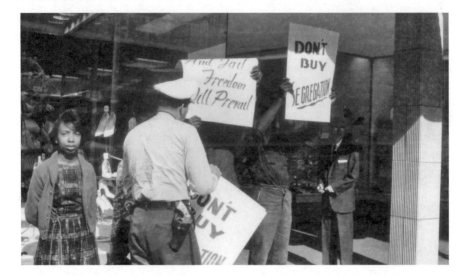

Children were at the vanguard of the protests in Birmingham, whether pickets, sit-ins or marches. *Image courtesy of BCRI Archives.*

not going to school, because you're going to the church." So I said, "Yes, you're right"…And my friends and I went on to the church, and when we got there, it was a bunch of other people there, and we had already been assigned to what we were going to do.

So we got in our little groups, and from then on, we were still being, they were still teaching us, telling us what to do in case something should happen. So we listened, and then it was time to march. Well, we got maybe about half a block from the church, and we were arrested. There were a lot of paddy wagons out. As I can remember, I was one of the first ones getting in the first paddy wagon…

I was still thinking I'm not really going to stay here. Like I knew I was going to get out that night until that night came and nobody came to pick me up, and I was terrified.

She stayed for nine days at the Birmingham City Jail, incarcerated in a large cell with bunks, locked up with angry people arrested for other reasons and prostitutes:

It was horrible. I never want to experience it again. And I never went back. But it was terrifying because we were in a real jail where they had real criminals, and my girlfriend and I, we were so devastated about being there,

we slept together because we just didn't want anybody to say anything to us. And there was no privacy there…The food was horrible. We didn't eat anything other than junk out of a machine.

Despite the unpleasant and frightening circumstances, Tyson says she did not call her parents:

I didn't because, like I told you earlier…my parents didn't want me to participate because my father worked for the City of Birmingham and he thought he would lose his job. So I knew if I called there, they wouldn't come and get me out, so it was no reason to call. So I just stayed there.

And I don't know if, I don't remember if they just decided to let us out, but getting out of the city jail, a state trooper transported us from the city jail to the juvenile court, and then my mother came there to pick me up. But going to that juvenile court was like going to heaven compared to that jail we were in.

GLORIA WASHINGTON LEWIS-RANDALL

Gloria Washington Lewis-Randall, a retired schoolteacher and social worker, has told many times about how she became a foot soldier in the Birmingham movement. Her account figured prominently, for example, in the film *Mighty Times: The Children's Crusade*. She tells with pride and enthusiasm about how, as fifteen-year-old Gloria Washington, a student at Parker High in Birmingham's Smithfield neighborhood, she took her place among the demonstrators of 1963.

"Dr. Martin Luther King was speaking at a lot of churches, preferably Sixteenth Street Baptist Church," Randall says.

> *He was spellbinding. I would listen at the things he would say, and I recognized that all of the questions that I used to ask my mother—"Ma, why I got to sit in the back of this bus?" Or "Why can't I go to the zoo and ride a train?" Or "Why can't I go to East Lake Park this evening"—you know on Sunday evenings when you're riding after church? And she'd always say, "That's just the way it is."*

In contrast, she says, even black children could watch local television and see that whites in the same community could enjoy lives free from the fear and restrictions that African Americans in Birmingham faced daily. Gloria, like many of her peers, was tired of being told that she could not have equal rights.

As a teenager, Gloria Washington had a harrowing experience in jail when she was arrested during the Children's Crusade. *Image courtesy of Gloria Washington Lewis-Randall.*

"Well, we were that era that said, 'Why not?' I was that era," she recalls. "I wanted to make a difference. I could not understand why my parents were dead-bound on me going to college, achieving and being all I can be—and I'm a second-class citizen, probably a third class, you know? I was being called racial slurs and spit on if I went to town, and it just bothered me. It really caused me great pain. I still have those scars." She was determined to work for change.

"What encouraged me to march, in addition to me listening to Dr. King…There was a fiery young minister named James Bevel, and he was closer to our age. I imagine Bevel wasn't no more than about his early twenties. We could readily relate to him," she says. "We talked to him, and he said, 'This is not working. We've got to implement some more things.'"

Gloria marched several days, notably on D-Day—May 2, 1963—the first day of the Children's Crusade.

As she recalls it, many students had skipped school that day, waiting near their radios to hear a signal—a certain song to be played by activist and popular disc jockey "Tall" Paul White. When the music came on, Gloria was in the driveway of their home watching her father, a coal miner, washing his blue Cadillac:

> *My father was outside washing his car. He said, "Well, it's getting close to that time. You listening at the radio?" I said, "Yes I am, sir." He said, "Well, OK. I tell you what—go back in there and put you on another pair of pants, so when the water hoses and things hit you again, you won't be able to feel as much. Put you on another shirt." Which I did, and for good reason.*

You would fall. You didn't know if you would hit the pavement or hit the glass and bust it out in the store windows. He was just looking out for me.

Her father, she says, "was very encouraging." Like many breadwinners, he supported the movement but not by demonstrating. An arrest could, and often did, mean the loss of a job. "He could not afford not to be able to take care of me and my mom."

Her mother, on the other hand, didn't know her daughter's plans. She would not have approved.

When Tall Paul's record played, Gloria and the other kids started walking toward the gathering point: Sixteenth Street Baptist Church. "We came from every direction. I mean, you were meeting people on every corner," she says.

At the church, she recounts, "you get fired up like a rally, like a pep rally. That's when you were given your instructions."

That day, when she left the church, Gloria got a look at Bull Connor's white tank—the armored vehicle he would sometimes bring to intimidate demonstrators. It had just that effect on her. "That put fear in my heart," she says.

Bevel came up with this plan: since they were cutting us down every corner, let's go a different route. So my route was straight up Sixteenth Street all the way up to Eleventh Avenue, where that Jewish cemetery is, then we'd turn right, go to Nineteenth Street and then we were passing by police blockades.

The goal? "To get to city hall. And once you got to city hall, you fell on your knees. Police would pick you up and throw you in a paddy wagon or bus or whatever and took you to jail."

Young Gloria, like other marchers who reached city hall, was carrying a sign. "Mine sign said, 'We shall overcome,'" she remembers. She held up her sign for a moment, fell to her knees and then felt herself being lifted up by two police officers and put into a paddy wagon with a group of boys, many of whom she knew from school:

They threw me in the paddy wagon with all guys. They took them to the city jail on Sixth Avenue South. They dropped them off…From there, because we were young enough to go to the juvenile [facility], they took us to the juvenile. But they were full. So then I had to go to the Fairgrounds. But I was only there a few days. I was there, maybe, about five days.

"You even had some mothers, some parents, come out to the fence to see if they could see their children," she recalls.

Gloria, like others arrested during the demonstrations, recounted how one or more police officers were involved in the sexual assault of a young girl who had been arrested for demonstrating. The girl, whose full name Gloria could not remember, was, in Gloria's words, "light-skinned, pretty hair, cute little figure, you know…She had been through a lot. [She] had been hurt back there at the Fairgrounds when she was brought in. And during the night, this guy with a limp, a white officer, came in searching for her in the night because they had been talking about this pretty girl. And she said, 'Please don't let them hurt me anymore.'"

In Gloria's account, she was among several incarcerated teens who interceded, taking the night stick from the officer and fighting him off. "He didn't hurt her at all because she was moved after that," she said.

Gloria says that because of that, she was removed from the Fairgrounds to the Jefferson County Jail.

While there, she was made to clean the floor with a toothbrush. When she complained of having rheumatic fever, she said the matron "told me to stay in the sweat box until my heart got better.'"

Gloria says she remained in jail as long as she did because the movement had run out of money to bail the children out of jail and because, when she was moved from the Fairgrounds to the county jail, she got lost in the system. "My mom couldn't find me," she said. "My mom tried for weeks to get me out. But they kept telling her, 'We don't have children in the county jail.'"

Her arrest created problems at home: "My mom was very angry. She almost divorced my dad because when I finally did get out, almost a month later, she was very disturbed."

Gloria credits her release to her mother's boss from the department store Tillman and Levinson. After Mrs. Washington was unable to secure her daughter's freedom, her boss, who was white, went to the jail and requested that the child be turned over to him.

Her time in the county jail was nothing short of "horrendous," she recalls, noting that in the "sweat box" there was no bathroom facility. "When you come out, you're dirty, you're nasty; your hair is sticking on the top of your head. It was terrible. It was belittling."

Although Gloria says she would have gone through it all again, her arrest and detention changed her outlook in the years to come. "It made me leery of people," she says. Before the arrest, "I used to have a very, very trusting spirit towards anyone. But because of the

Gloria Washington Lewis-Randall is proud of her status as a movement foot soldier and regularly finds ways to help others share their histories of involvement in the civil rights movement.

humiliation and the pain and the hurt and the scars, I wouldn't allow people to get close to me at all. I didn't trust anyone. It wasn't just toward whites. I didn't trust anybody."

Later in life, Gloria got involved in social work. And rather than feeling bitter about what she went through, she views her time in the civil rights movement as a divine experience. She helps other foot soldiers find their voices and tell their stories, and she even wrote a poem about her experience: "I Remember I Couldn't." As she looks back on that time in her life now, Gloria says, "God took ordinary people and just made them do extraordinary things."

"I REMEMBER I COULDN'T"

By Gloria Washington Lewis, February 11, 2005

I remember going to church.
I remember going to school.
I was taught the love of God.
I was taught the "Golden Rule."
I remember encountering bigots.
I remember the piercing screams.
I remember anger and frustration
And the crushing of life-long dreams.
I remember my dad saying,
"Be the best that you can be!"
But I was so confused
Because I didn't feel free.
I had been told to sit
On the back of the bus.
I've been called a "nigger."
I've been spit on and cussed.
I couldn't drink from a fountain
Nor eat at a counter downtown.
And though I smiled at everyone,
I was always returned a frown.
I couldn't go to the park
Or ride a train at the zoo.
Because my skin was black
And the color would bleed through.
I remember saying to my mama,
"Mom, this isn't right!
Why do these people hate me
Is it because their skin is white?"
I didn't wait for an answer.
I just took to the streets.
And hordes of other children
Joined in with my beliefs.
We were thrown into jails,
But soon dignity came.
And in nineteen sixty-three,
The bell of freedom rang!
The story is not over,
For many said that I shouldn't.
Yet victory has been won
I REMEMBER I COULDN'T.

CAROL JACKSON WALTON

After retiring from a teaching career in Flint, Michigan, Carol Jackson Walton says she's contemplating moving back to Birmingham, where as a young woman, urged on by her family and supported by friends such as Myrna Carter Jackson, she played a role as a foot soldier in the city's civil rights movement.

When she was a teenage girl growing up in segregated Birmingham, young Carol Jackson thumbed her nose at the color line every chance she got.

She would go to the Paramount Barbecue, waiting to see if she would be served as white women were, or to Liberty Supermarket, where she would drink deliberately from the "whites-only" water fountain. "And I would call my sister—'Hey, come here Gwendolyn. Taste this! They're right! This water is colder than that 'colored' water over there."

Her sister wouldn't drink. "I think," Carol says, laughing at the memory, "they always thought, 'Girl, there's something wrong with you.'"

Challenging the status quo might have seemed a little crazy at the time in a city where resistance to racial change came in the form of police harassment, Klan intimidation rides and the terror of dynamite bombings, but as a young girl, Carol couldn't help herself. She felt compelled to resist in various little, but no doubt annoying, ways.

"We would go downtown, and I would jump on the white elevator and I would say, 'Ohh, you can't believe the ride on that white elevator!' I would get off the elevator talking very loud about it and everything," Carol says. "And they would just stand there and look at me...I didn't have fear, but I just didn't like

Carol Jackson Walton remembers being "mesmerized" by movement leaders and the mission to win equal rights as citizens in Alabama. *Courtesy of Carol Jackson Walton.*

the fact that we didn't have the same advantages that white people had."

None of the white people in the stores where she flagrantly violated the color line ever did anything to her, but experiencing the segregated conditions day after day did affect her. All of that was before there was a mass civil rights campaign in Birmingham.

Fast forward to 1963. The Birmingham movement was underway. Carol was twenty-two.

"I had had heard about the movement, and my mother had always kept us members of the NAACP and kept us abreast of how things were in Birmingham. I was always aware of not liking how black people were treated," she says.

At the time, she was attending Daniel Payne College, on the city's northwest side, and studying what was called general education. She also was contributing her voice and her presence to efforts to bring about change.

"I sang because I had a pretty great voice at that time," Carol recalls.

> *Singing and marching. Basically, my whole family was involved. My mother did not march. She was working for Dr. A.G. Gaston* [a wealthy black businessman in Birmingham], *and she and my aunt would always barbecue on Fridays, sell the barbecue, and I would take the money down to the meetings to help pay for the lawyers so that we could make sure we had lawyers to represent us to get us out of jail when we went to jail.*

There was a civil rights movement choir that developed during that period, but Carol was not part of it—for a simple reason, she says. "I never

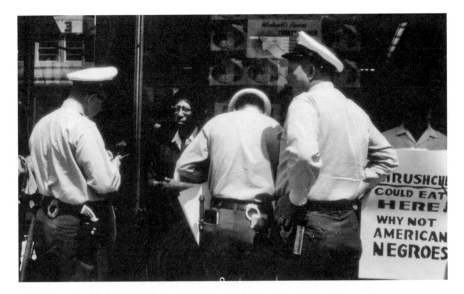

"Krushchev could eat here. Why not American Negroes?" Part of the movement involved teenagers and others picketing downtown Birmingham's segregated establishments. *Image courtesy of BCRI Archives.*

did join the choir because I was always spending my time basically going back and forth to jail."

On one occasion, she was one of the picketers targeting downtown department stores like Newberry's, which were both a constant manifestation of racial discrimination and seen by movement leaders as key to efforts to force the city's economic engines to slow.

"I remember marching. We came across the park from Sixteenth Street Baptist Church, and we went on downtown, right there in the front of J.J. Newberry's," Carol says. "I remember carrying a sign that said, 'Nikita Khrushchev can eat in here, why can't I?' And that's where the police stopped me. I remember the police walking up, taking my sign from me. Asked for my name and my age. The next thing I know, the big black paddy wagon was pulling up, and we were getting in."

From there, she said, "they took us downtown, I remember going on the tunnel. Got out of the wagon, and we went in from there."

She had been demonstrating with her friend Myrna Carter, walking in a line behind Martin Luther King, Ralph Abernathy, Andrew Young, Julian Bond, blind singer Al Hibbler and Margaret Askew, she said. She and Myrna were arrested together:

I recall we went in, and the city matron, she kind of was really abrupt with me. She grabbed my arm, and I remembered her saying—because it hit me like somebody had slapped my face—I remember her saying, "Oh, here's another little half-white one." And I looked back at her. I was astounded. I couldn't understand why she would say this. And she kind of pushed me, like, in towards the bars, and I can remember hitting my head on the bars. But I never said anything.

Once we were thrown into the cell and I heard the clicking of the bars. That's when I knew. I said, "Oh, my God. Now this is where I have no freedom. I didn't have any freedom out, now I surely have no freedom." And when I sat down on the cot, I said, "I can't sleep here because this is horrible." The bed was hard; it was a nasty army-like blanket—it was wool, and it was kind of a greenish coloring. And we went in to go eat, and oooh, the food was horrible! The stench of it just would make you want to regurgitate.

Some might imagine that civil rights marchers were uniformly heroic, facing resistance to the movement with stoicism—unafraid, undaunted, unfazed by whatever happened. But for many, that was not the case. Although she demonstrated for what she knew was right, Carol, given a choice, would have welcomed better accommodations.

"I often tell people, and the children I taught for years," she says, "'You need to get an education because you don't want to do anything to jeopardize your freedom. Jail is no place for anyone. No human being has any business locked behind the bars.' I realized that when I went to jail. That's what made me know I could never commit a crime because I couldn't live in that kind of facility."

On that occasion, she was in jail for three or four days and then faced a court appearance that might mean release:

I can recall my aunt telling me, the night before we went back to court, she said, "Oh, be prepared, because you're going to go back to jail tomorrow." I said, "No, they're going to let us go."

Sure enough, when we went back to court, when we walked in, sat down, they had a projector. And when they showed the pictures, my picture was the first. I said, "Oh, God, they've even given me a number." My face came up on the screen. I had this number on me. And then I heard the judge say, very profoundly, "Give those niggers ninety days in jail and a hundred dollar fine." And we were put back in jail. So we were there over a week or more that time.

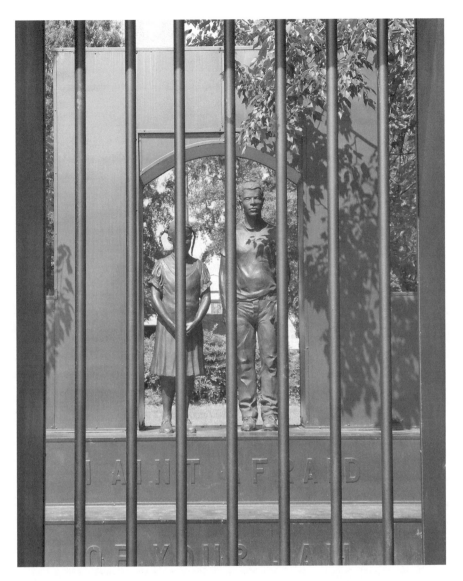

Visitors to Kelly Ingram Park will see sculptures memorializing what demonstrators sacrificed, like this glimpse into the experience of children behind bars.

Carol recalls getting out of jail eventually, at midnight:

My mother would always be there waiting for us because someone would always call her and let her know, "Mrs. Jackson, they're going to let Carol and those out of jail. It's going to be late. Be there to pick them up because

we don't want them on the street because if they pick them back up, they'll put them back in jail for vagrancy."

Mrs. Jackson, Carol's mother, was there near the jail waiting for the girls in her white Valiant:

She picked us up, carried us home, and then that [Easter] Sunday, I can recall, we went down to New Pilgrim Baptist Church, and Reverend Smith prayed that Sunday. And he prayed a prayer—I recall that so vividly—he was asking the Lord to let it thunder and roar like never before, and all of a sudden it seemed like the heavens opened up and the angelic choir from heaven—it sounded like people clapping their hands. That's how loud the thunder was...Oh, my God, were people ecstatic and screaming and hollering, calling on the Lord and praying. We came out of the church, and we were standing in the middle of the street.

Carol had her baby niece on her hip:

I remember the fireman walking over to my mother and saying, "Take your daughter's baby because they're going to put the water on them today." And my mother took my niece from us, and that's when we started singing, "Not Gonna Let Anybody Turn Us Around," and we began to march down Sixth Avenue straight to Memorial Park. And we got to the park, and we kneeled down on our knees.

And that's when something else remarkable happened, something reported by numerous marchers who were present at Memorial Park:

And I remember I saw the firemen coming up with the water hose. And I heard Bull Connor say, "Put the water on those niggers." And I heard the fireman when he said, "If you want the water on them today, you'll have to do it your damn self." And he got down on his knees—because he wasn't that far from kneeling—next to me. He kneeled down and began to pray also.

The marchers had been prepared for whatever would come. Instead of dressing in their Easter best, as was tradition in the black community on that holiday,

no one dressed up. Everybody was in coveralls, and the women just wore housedresses. And that was unusual because Easter Sunday was a big Sunday for black people. Everybody would be dressed to the max with their big brimmed hats on and children dressed in all their frilly clothes. But nobody was dressed. And that's when the merchants downtown really felt—they felt the power of our demonstration. Because nobody was spending money.

When she looks back now at that whole period of demonstrations, resistance and change, Carol sees herself, and her fellow marchers, as having been touched by something special, something she characterizes as supernatural:

I know that I was in a state, like someone had hypnotized me. Mesmerized. Because each time we went to a meeting, I never in my heart purposed to say, "Oh, I'm going to march again tomorrow." Because each time I marched, it was like I would have these experiences that "I can't do this anymore…I cannot march anymore. I can't go to jail anymore. It's frightening. I'm afraid. I'm going to lose my life." And when we would go to the meetings and Dr. King would open his mouth, then you were on your feet to start up again to march. When I think about it now, it's almost like we were hypnotized. Mesmerized.

Even that Sunday, marching to Memorial Park, I told Myrna it was like floating on air. You have to have been there to know how it felt. It wasn't like a natural experience. It was something out of the supernatural. That's why I know that God was in this plan.

She says she marched in fourteen or fifteen civil rights demonstrations. But the last time she intended to march—for voting rights, from Selma to Montgomery, on March 25, 1965—she didn't make it:

That morning when I got up, I told my mother, "I'm not doing this today." For some reason, my mother was adamant. "Oh yes, you're going to march. You've come too far. I tell you what I'm going to do, I'm going to drive, and so you won't have to walk, neither ride one of the school buses. You can ride in the car." But I really was resistant to the fact of doing that that day.

About ten o'clock that morning, something happened that would affect their ability to participate in the historic march. "Right there in Prattville,

Alabama [just north of Montgomery], my grandmother was talking to me about praying," Carol recalls.

> *I said, "Of course I pray. I prayed this morning for God to give us strength and to take us safely." That's the only way I could have kept marching because I prayed constantly. And all of a sudden, I felt my mother's car...it's like it veered off the road, was up in the air like a bullet. And when it came down, it came down in a ravine.*
>
> *How I got out of the car, I can't recall. When I came to myself, I was on my feet, no shoes on. And I looked and the car was just turned upside down. And my brother and I got out and tried to get my mother out of the car because the steering wheel had her kind of pinned in. We finally got her out, laid her on the ground. And there was a minister, Catholic priest. He came by in the marching, walking. He came over and began to massage her neck. He said, "I'm doing this to keep her from going into shock."*
>
> *People were passing on the buses, and the walkers were going. It was awesome. But I knew then, I cannot keep marching. I probably would lose my life.*

Once it appeared that she and her mother were going to be OK—although her mother's lung was punctured, her ribs were fractured and it turned out she had a concussion— Carol's brother Donald and her aunt joined the marchers. Carol, her mother and her grandmother waited for the ambulance.

But when rescue workers arrived, Carol says, the drivers attending to the injured women reminded them how little progress had been made in the hearts of some Alabamians two years after the massive Birmingham demonstrations:

> *I was about the only one really alert. And they said, "We should just throw these niggers off in the river." I had to be very stern. I had to take control. I said, "You're going to take this ambulance straight to the hospital, and you better not touch anybody in this ambulance." And we did make it to the hospital. I've forgot about the name of the hospital. But I know we couldn't get any medical treatment until Dr. Gaston sent the ambulance from Birmingham, Alabama, to pick us up. We didn't get any treatment until we got back to Birmingham, St. Vincent's Hospital.*

Nine or ten hours had passed between the accident and the treatment. But they all survived. "It was very traumatic. The same day we had the accident, Viola Liuzzo got killed that night." Liuzzo, a white civil rights activist

from Michigan, was murdered—shot in the head in a drive-by shooting perpetrated by Klansmen after the march—as she drove marchers back to their homes. Among the four Klansmen in the car was the controversial FBI informant Gary Thomas Rowe, who received immunity and witness protection, despite claims by the other Klansmen that he pulled the trigger.

Although Carol's career in education took her from Birmingham to, at age twenty-nine, Michigan, the things she suffered for the movement left indelible impressions. "I don't like crowds," she says. "I have panic attacks, and my doctor said that probably comes from all the stuff that I went through in the marching. Because when I was younger I would say I was—I've always been a go-getter. I've always been a person who stood up for what was right."

Back in the 1960s, Carol felt the duality of being afraid but at the same time being compelled to stand up. And so today, panic attacks notwithstanding, she again feels an urge to take on a cause on behalf of social justice. "I'm trying to move back to Birmingham because I know there's still a lot of work to do," she says. "I have to complete the work I started with the marches in Birmingham, Alabama. There's still a lot to do. We've made some strides. But as I look at things today, I tell my grandson, 'Get yourself a good education.' I want you to know the new day's slavery is jail."

MYRNA CARTER JACKSON

A strong believer that the truth of the civil rights movement needs to be told, Myrna Carter Jackson is quick to invite scrutiny on her record, which includes her jailing in 1963 as part of the campaign against segregation in Birmingham. Back then, she felt passionately that something needed to be done. Today, she feels just as passionately that succeeding generations not forget.

Talking to a group of black Parker High School students, the former Myrna Carter relates how, as a young woman not much older than they are now, just a few years out of Parker High herself, she became a foot soldier in the civil rights movement in Birmingham.

She shows them, projected on a screen in their history class, an image of her jail record, proof that she was one of those arrested during the demonstrations in 1963 that broke the back of legal segregation in Birmingham. "See, April 11 is the first time I was arrested."

She wants the Parker students to know the importance of records like this in verifying who did what. As she speaks, the city is commemorating the events of fifty years earlier, and Myrna contends that many people are grabbing undeserved glory by claiming they did things for the movement that they really didn't do.

She's happy to prove that she did what she says she did:

> *This did not come from Myrna Carter Jackson. This came from the police department. Everybody understand? I was fined $100 and five days in jail. And look—they even gave the name of the officers that arrested me.*

Myrna Carter Jackson strives to educate students today, including those at her alma mater of Parker High, about their heritage and the struggles required to win their rights.

Bond was $50—for standing up for that which is right. That's why I was asked not long ago, "How do you feel about how the youth are acting now, in [view of] what was done in the '60s and before?" I said, "It hurts."

So when you act up, or cut up or are disrespectful to yourselves or each other, it hurts. When you're disrespectful to your parents, it hurts. Because so much has been done for you. And we expect you to do far, far greater things.

Myrna, vice-president of the Metro Birmingham Branch of the NAACP, speaks often about what she and others in the movement did, presenting to groups at schools, churches, panels and discussions at the Birmingham Civil Rights Institute. Back in the late 1990s, she was one of several foot soldiers interviewed for a series in the *Birmingham Post-Herald*. "I'm grateful for the small part I had to play," she told me back then. "It's an honor and a privilege to say you put forth an effort to correct a wrong."

These days, one of the wrongs she wants to correct relates to fabrications about involvement in the movement. She recounts how she warned Hezekiah Jackson, president of the Metro Birmingham NAACP, that his Foot Soldier Finder project would bring a lot of pretenders out of the woodwork. "I told him you are opening Pandora's box," she said. "Some of these people are not telling the truth."

She recounts an example of a man who came to the Birmingham NAACP office to retrieve a file of papers his sister had delivered, claiming to have evidence that her brother was a foot soldier and should be honored for his role in the movement. In fact, though, the man had been in Vietnam during the movement. He had not been a civil rights demonstrator, and he did not want anyone crediting him for something he had not done. That was admirable, Myrna says. "Just tell the truth. The truth will stand on its own. And nothing you did is insignificant. If you helped a person to cross the street—that's significant. But you don't have to say you built them a house…Just tell the truth. But when you start lying, it takes away from it."

Here, then, is part of the truth about Myrna.

Growing up, her house was a block away from Birmingham's Shields Elementary School in the eastern part of town, but there came a time when the city had to expand the overcrowded school. So Myrna went for a time to nearby Thomas Elementary, which meant passing by the large Cunningham Elementary School, where only white students could attend.

It also meant walking each day through an area populated by poor whites called, in the pejorative lingo of the day, "Cracker Town," Myrna said. While in third or fourth grade, "we were having to walk down through there. And they would wait on us. They'd be eating on their porch," Myrna says. "When we got there, oh, they [the people on the porch] thought it was funny to hold the dog on a chain; then when we get a certain distance, they would let them go and the dogs would run at us. And we'd run for life and death."

One day, Myrna's brother and some of his friends told the younger kids to walk ahead of them as they passed by the dog owners. Myrna's brother, who was in the school band, and his friends would come up right behind them.

"Well, this particular day, when they told us to go on ahead, we heard the dogs. And we all of a sudden heard [the sound of a dog letting out a sharp cry of pain]. And we looked back. My brother had hit one of them with his trombone case. Then they had to run. And we didn't stop till we got home."

Later, there were repercussions, she says. "We knew we couldn't go through Cracker Town anymore. So we started going out the back of Thomas School, going down the railroad tracks, which were called Maylene tracks. Do you know those white people on that train would stop on the trestle so we couldn't pass?"

They were forced to go down into the creek and up a hill. "Do you know they would shoot steam out of the train? They would put steam on us."

Given such experiences growing up, it might not be surprising that, in time, Myrna would get involved in the civil rights movement. She joined the demonstrations after March 1963, when she got a phone call from her best friend, Carol Jackson.

"Carol called me one day, she said, 'We ought to go to this movement meeting, see what what's going on with this movement,'" Myrna says.

> We went, and it was so invigorating to see a black person speak out as Reverend Shuttlesworth [did]. He doesn't get the notoriety that he deserves. Whereas Dr. King was laid-back and eloquent, Shuttlesworth could identify with everybody because he told you how he felt...The idea of black men standing up, talking about white people like that—that was unheard of. To be that bold? And that night, I remember, Reverend Shuttlesworth said, "I'm going to de-horn the Bull!" I'll never forget it.

Shuttlesworth was, of course, referring to Eugene "Bull" Connor, Birmingham's most outspoken segregationist politician who, as commissioner of public safety, controlled the city's police and fire departments and their police dogs and water cannons. He and Shuttlesworth each represented a side in the battle for the city—at least as far as the question of whether the city would integrate was concerned. For a black man to speak so defiantly against the white authority behind segregation was a signal that times were changing.

During movement meetings, after the speakers finished, people were invited to commit to the cause and sign up. It was called "Commitment Hour," a reflection of the order of service in the Baptist Church, which followed up a sermon with an opportunity for new people to join. At the movement meetings, Myrna says, "that's when you give this lady down there

The site of the most horrific single act of Klan terrorism during the movement, the Sixteenth Street Baptist Church remains as a reminder of its role in organizing demonstrators.

your name, telephone number and address and everything. Then they would tell you when to come back. Well, we were told, Carol and I were told, to be back at Sixteenth Street Baptist Church the next morning."

When they arrived, they went into a group session with Andrew Young, then one of King's right-hand men. The purpose of such sessions was to prepare demonstrators to maintain a quiet nonviolent stance while marching. "We were gathered in the basement, and they told us the rules and the regulations,' Myrna says.

> *"If anybody says anything to you all, spits on you or anything"—you couldn't say a word. We had to make that commitment. They said, "If you cannot do that, then you cannot demonstrate. There's other things you can do, but you can't demonstrate, if you can't take it. Those of you who feel like you can take it, that's who I need."*
>
> *He said, "I want some of y'all to come over here with me." He had signs. He said, "Line up in pairs. J.J. Newberry's is our destination. Go down Sixth Avenue North to Nineteenth Street. Turn right on Nineteenth Street…"*

The marchers left the church singing, "Ain't gonna let nobody turn me around," Myrna recalls, belting out the chorus of the now famous freedom song. Then Young turned to another group of marchers, the group that included Myrna and Carol.

> He said, "I want you to line up in pairs. I want you to go down Sixteenth Street North to Second Avenue. J.J. Newberry's is your destination." Well, when we got out there, we saw that Bull Connor and the paddy wagon and everybody had followed that first group...That was a decoy group. That let us get all the way to Newberry's before they realized what had happened. Then Bull Connor got mad because he realized they had made a monkey out of him...
>
> It was the first time we had made it all the way there. We made it all the way to Newberry's.

Once there, she encountered a well-dressed white woman who asked her a question that revealed how deluded some Birmingham residents were, both about where the marchers actually came from and why they bothered to put themselves at risk. "She said, 'Why don't you niggers go back where you came from? The niggers here are satisfied,'" Myrna recalls. Myrna wanted to tell her how wrong she was, but because she had been trained not to respond, she said nothing. The woman walked off.

The marchers, on the other hand, were arrested. Myrna was shoved into a paddy wagon with her fellow demonstrators. Being tall, Myrna had trouble fitting into the confined space of the police vehicle, which had a partition down the middle and benches against either side. Finding room was especially difficult as police crammed more and more protesters into the same space.

"They just packed us on, and they took us to city jail. We were in jail a couple of days," she says. "When we got to jail, they put us in cells with regular prisoners, but they weren't hardened criminals."

In May, Myrna was arrested again for protesting:

> The second time we went to court, and we had made plans to go down to Smith and Gaston steakhouse restaurant after court. But first, the judge dispensed with his more famous prisoners. They called Dr. King, and he went up with his wife, Coretta. Then they called Abernathy, and he went up with his wife. They called all of them off that front row. Well, we couldn't hear what the judge was saying to them, but we noticed that they

all turned and went out the side door by the judge's bench. Then, they began to call our names. They would call so many names, and we would go up there. They put us back in jail from the courtroom because they [the movement organization] didn't have any money to pay our bail. So we were in jail that time about nine days. That's when Harry Belafonte and all of them were trying to raise money to get us out of jail because there was no money.

While they were in jail, they tried to keep their spirits up:

We were taught to have prayer meeting three times a day and sing. And that's what we would do. But one thing about it, they [the jailers] did not make us do any work. I'm not going to lie. We didn't do any work. We'd just sit around all day and talk or whatever. But they worked the real prisoners. They had things in the laundry to do, they had cooking, they had to do a lot of little chores and things around the place.

Although the jailed demonstrators did not have to work, the conditions were hardly pleasant. The jailers would not accept outside clothing for the demonstrators, who had to remain in the same clothes the entire time they were locked up. "They wouldn't accept clothing for us," Myrna says. "They wouldn't take anything for us."

There were no walls and no privacy. And, Myrna says, they had to sleep on the bare metal springs of their bunks; the jailers had removed or did not provide mattresses for the protesters:

Word got out about the treatment that we were receiving there and having to sleep on the bunk [without a mattress], and Robert Kennedy was going to send somebody from the Justice Department to inspect the jail. When the people in the jail found out, they got the trustees to bring mattresses up there to our cells. So we made a human lock. We locked our arms and wouldn't let them in that door...We knew that when the Justice Department people left, they were going to take them back anyway. So we made that human chain around that door and wouldn't let them in. And they threw those things in that hallway...And they had to come and get all those mattresses and things and take them back because we wouldn't let them in there.

The second jailing was extended because the movement, which had been raising money to bail out the protesters, found itself unable to bail out so

many. "That's when Harry Belafonte, Sammy Davis Jr. and several other people got together and gave a big concert to raise money," Myrna recalls.

Her time in the Birmingham movement leaves Myrna with a profound appreciation for having a part in history and for having met those who galvanized something so important to the well-being of future generations. "I believe if Dr. King had told us to walk off a cliff we would have done it," she told me in 1999. "I'm a firm believer that the Lord supplies a generation every so often with a Moses, and he was ours."

Years after the movement, Myrna finished college and became a social worker. "I worked with the people from Katrina and helped people get in school," she says. She has devoted much of her time to civic organizations, working with the Civil Rights Institute and the city Housing Authority, as well as Birmingham's Community Action Committee, which began as a biracial effort to heal the wounds fresh off the civil rights conflicts after Bull Connor was unseated from office.

She takes pleasure in talking to young people, particularly young African Americans, trying to instill pride in them for the accomplishments of their ancestors. "The movement," she says, "started when they brought our fore parents over here on the slave ships. That's when the movement started.

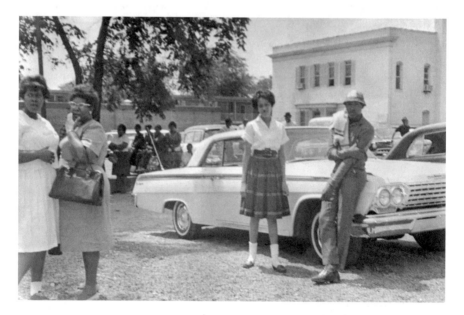

Women and schoolgirls played major roles as foot soldiers in the civil rights struggles in Birmingham during the 1960s. *Image courtesy of the Birmingham Public Library Archives.*

Don't cut those people short. We're on the shoulders of our ancestors who were kings and queens and who were strong-willed and intelligent people."

That past is to be embraced but also built upon, Myrna tells the students at Parker High. In her view, that is one reason so many ordinary people found the extraordinary will to risk everything in the civil rights movement. "The boldness that we had, it wasn't done for show. It wasn't done for any type of notoriety. It was done to make a better quality of life for my people."

CAROLYN WALKER WILLIAMS

S ome people who got involved in the civil rights movement in Birmingham were prompted by a significant event, an incident that provoked outrage, that compelled them to join the protests. But for many others, it was the accumulation of small, everyday injustices that drove them into the streets.

The latter was the case for Carolyn Walker Williams. A soft-spoken woman who loves and seems to be surrounded by her family all the time, Williams started noticing things pretty early in life.

"As a child I knew something was wrong," she said in her neat living room in North Birmingham.

> *I lived in east Birmingham, and I knew something was wrong. Our bus was 22 Tarrant. And as a five-year-old child, I knew something was wrong.*
>
> *When we would get on a bus, there were seats available up front, and all we had was that little section in the back. That always bothered me. I knew something was wrong, but I didn't know what was wrong. And then a lot of times we would pay our money and have to walk to the back of the bus, and sometimes the bus driver would be mean and pull off.*
>
> *From that, I knew something was wrong, and when I had the opportunity at sixteen years old—I was a junior in high school, George Washington Carver High School—I said, "This is my opportunity" to do something about whatever the injustice was.*

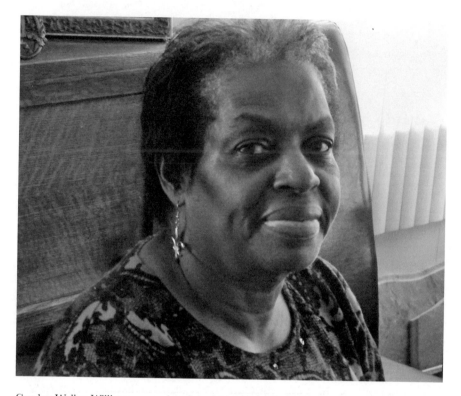

Carolyn Walker Williams remembers her parents' mixed reactions to her involvement in the civil rights movement. She says the experience changed her life.

Williams turned sixteen in 1963, the year Birmingham shook off the official segregation of public accommodations, but not without a lot of violence and resistance to change. The movement came to Carver High, as it did to many Birmingham schools, in a message carried by young recruiters, "students from different colleges who came to talk to us after school," Williams said. "We had a mass meeting every Monday, and they would tell us about Dr. King and Reverend Shuttlesworth and the movement and wanted to know if we wanted to participate and make a difference."

The meetings Williams attended were held at New Hope Baptist Church in Avondale, one of at least sixty churches in Birmingham that supported the movement by hosting mass meetings. She remembers about ten students from Carver attending the meetings, but they were hardly alone. "Students were recruited from every high school," Williams said. "Hayes High School, Ullman High School, Carver High School." Students attended meetings based on where they lived.

Carolyn and her brother became regular attendees. But they had to get permission first, and that consent came from their mother. "She was very strict with us. We were the type of children, when we got out of school, my parents knew everything we did," Williams said. "One day, I told her that we wanted to stay to go to a mass meeting, and I explained part of it to her. And so she said, 'OK.' She would give us thirty minutes to be home. She had to walk us, because a lot of times we didn't have the money to ride the bus. And she asked me what time would the mass meeting be over with."

Mrs. Walker did not really understand completely what was happening in the mass meetings. Her mom "cleaned up white people's homes over in Norwood…But she only did it one day a week, if my daddy allowed her to do that. He preferred her being at home taking care of the family."

But she reasoned that she could not keep her children under her wings all the time and that what they were doing seemed to be worthwhile.

Her husband, on the other hand, took a different view. Besides being a pastor, Carolyn's father held down a job for McWane Cast Iron Pipe Company. "He never depended on the church to take care of him. He always had his own job," she said. But that meant having his kids involved in the movement could be a problem. "On his job, they were informed that if their children got involved, and they got wind of what was going on, and their children had participated, they would be fired from their job. He was the president of the union there, and he operated a machine. He had had that job probably about twenty years," Williams said.

So there was much at stake if the Walker kids got involved. And the civil rights movement was hardly ever a real source of conversation in their home. But even in a family where, as Williams said, "the only things we did was go to church and family functions," the reasons behind the anti-segregation initiatives were apparent.

"I guess one thing that influenced my mom was that she remembered when my daddy went to register to vote and he had to know how many seeds were in a watermelon, and he had to know how many clouds were in the sky or some dumb stuff like that," Williams said. Under the Jim Crow system, which was firmly in control of Birmingham politics for so long, officials had erected numerous barriers to prevent blacks from voting, as historian Solomon P. Kimerling noted in the January 2013 installment of *Weld's* civil rights history series "No More Bull."

In Alabama, the literacy test was a vital tool of voter suppression. In order to qualify to vote, a black citizen was required to answer questions,

usually about the laws of governance. As straightforward as that may seem, these questions were usually delivered orally and arbitrarily. Even crueler, whether an applicant answered some, any or all of the questions correctly was immaterial, as the decision to award a "passing" grade and allow the applicant to register was made at the full discretion of the registrar administering the test.

For Williams's father, the barriers to exercising his right to vote took on a more physical form as well: "I remember as a child, I was about eight or nine years old, my dad, running home, where he had gone to…these classes where they taught people how to register to vote. And the Ku Klux Klan ran him from Tarrant City. And he was out of breath when he got home. I remember that."

Seeing such things made Mrs. Walker see the potential in the civil rights movement that her children wanted to participate in—even if she didn't attend the meetings herself.

Williams said that at the mass meetings, movement organizers passed on their detailed strategy for avoiding entanglements with Birmingham Police until absolutely necessary:

> *They had informed us at the meetings how they wanted us to do so we wouldn't get arrested actually at the school—we would at least make it to downtown Birmingham. They informed us to just wear what you normally wore to school. In the classroom, take only the book—because we left at eleven o'clock. Take the book that you need so you won't be going to the lockers, you won't be doing stuff where they will stop you. Because the principals, and the teachers, everybody knew, and they had been warned by Bull Connor that they would lose their jobs if they couldn't control their students.*
>
> *So they told us when eleven o'clock came, to just stand up [at] your seats—which we did—walk out in the hall, leave the campus immediately so the police would not be called on you or they wouldn't be able to do anything to you. And that's what we did.*
>
> *They informed us to walk in twos, and we started singing freedom songs. They knew how to plan a peaceful protest. So we did. We walked in pairs like they said, and then when we got down to Thirty-fourth Street, that's where they met us. They would not come to your campus because that could bring on a lot of confusion, so they met us down there. We went on until we got down to Seventeenth Street in Birmingham.*

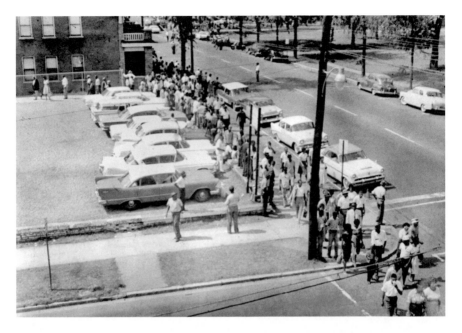

Surviving civil rights demonstrators remember how children streamed en masse from Birmingham schools to make an enormous public stand against segregation. *Image courtesy of the Birmingham Public Library Archives.*

We walked, singing, and people were looking and stopping. We were singing, "I'm not gonna let nobody turn us around" and all kinds of freedom songs…and we would clap our hands, but we had to continue marching. They told us to stay to the side of the road so the police wouldn't say we were blocking traffic. That way, we could really make it to downtown Birmingham if we obeyed. They [the police] were looking, but they couldn't say we were doing anything. The only thing we were doing was [being] out of school.

Still, Williams was among hundreds arrested on the day she marched, known as D-Day, the first day of what became known as the Children's Crusade. "We got arrested right before we got to Sixteenth Street [Baptist Church]. I never got to go in," she said. "They brought paddy wagons, and they shoved us in there like we were cattle. And we didn't know where we were going. So we went to county jail, city jail, and so, it's illegal to hold children in those jails, so they moved us that night."

She had known arrest was a possibility. But it was a shock to her father:

Now, my dad, the way he found out was the day I was arrested, on May 2nd, a Thursday. I had told my little sister, who was six, that if I did not come home at a certain time, that I'm probably in jail—and so is your brother—so tell Daddy when he gets off work at five o'clock to watch television. And she did. She couldn't hardly wait till five, so she said, "Daddy," and my dad went crazy. He told my mom that her responsibility to the children was to take care of the children because, you know, he took care of the home. And he asked her why did she let us do that?

My sister said my mom said, "You know, they are teenagers, and this is a different day and time," and she just went on. And to know my mom, I just can't believe that she let us go and do that.

Williams was incarcerated at the Alabama State Fairgrounds for eight days, separated from her brother, who was locked up in the Bessemer Jail for nine days. She didn't know at the time where her brother was. "That was the only thing that bothered me," she remembers. In time, she learned that her brother spent at least some of his time in jail, out in the rain.

The conditions at the Fairgrounds, while not exposed to the weather, were hardly homey. "Everybody was afraid because they [the jailers] were mean. They were mean and brutal," she said.

At the Fairgrounds, she says,

we slept on the gym floor, where they'd played basketball. You didn't have anything to bathe with, so you would use your clothing to bathe with. And we had to figure out how to do it because the police would walk in on you while you were taking showers and stuff. We brushed our teeth with paper towels.

There was a very nice lady that worked there—the food was better there—because I didn't eat at the other place. The cook there was very good to us—she was a black woman—and she told us, "As long as I eat good, you all will." She told us when she would work, and we knew to eat then.

Even so, Williams remembered, she didn't eat as she normally would:

By the end of the week I had probably lost ten, fifteen pounds. We slept on the floor. This was in May, and it was still cold. You would roll your sweater up and made a pillow out of it…You kinda took care of yourself,

and everybody looked out for the other one. We looked out for each other. If someone had to go to the bathroom, you'd go with somebody because you know how they were.

Her father, she said, tried to get his kids out of jail. The Central Committee of the civil rights movement was busily trying to raise money to bail out the hundreds of kids then overrunning the jails from several days of protest marches and mass arrests. "One day they came in and told us we were free and that we could call our parents. It was on a Thursday when I got out. They said they had paid the money, and we were free. We were happy, too."

Williams's dad came to pick her up. "He was glad to see me...He was more upset with my mom because he didn't know. He didn't think that she would really let us do anything like that."

Mrs. Walker "was happy to see me, too. She asked me what I wanted, and she fixed me my favorite meal."

Meanwhile, Carolyn grilled her for details. It was the first time she had not been allowed to go with her sister to an activity, and she felt left out. "But after that I started carrying her to different places when the movement would meet. So she felt better then," Williams said.

The very next day, they were called to a meeting with civil rights leaders, a mass meeting at New Pilgrim Baptist Church.

My sister...asked me if she could go with me. And the only thing my dad told me was, "Don't let her get arrested." I would have gone crazy if they had put me one place—me being sixteen years old—and put her another. I told my mom that I wanted to carry her with me, so she told me OK. She said, "Just take care of your sister." My sister still remembers that day, and she's sixty years old now.

It was so crowded that people had to sit on the floors. They had a seat for all of us. I let my sister sit on the seat; I told her I would sit on the floor right by her. We had a mass meeting. I think it lasted about two hours, and we sang. [Attorney General] Robert Kennedy had sent someone down, and he came on later. Dr. King [was there], Reverend Shuttlesworth...Reverend Abernathy was there, A.D. King [Martin Luther King's brother] was there.

A lot of the leaders had come. They talked to us and told us how proud they were and [that] what we did was going to change the world.

Then they told us to go back to school on Monday. But when we went back, we were expelled.

In all, the Birmingham schools expelled 1,081 students because of their participation in the protest marches. "We went to class," Williams said,

> *and they called your name. They knew who had participated because we had been out of school over a week. So we had to go back home. And we had a hearing at children's court, and at the hearing, Robert Kennedy had said, "That's illegal." Number one, we were children.*
>
> *But then they told us…that it may come up again, and you may not graduate. All the ones who were supposed to graduate may not graduate. They held us on bay for like nine months or so. You didn't know whether you were going to graduate or not.*

Eventually, young Carolyn returned to school. But things had changed. "When we got back to school, my principal there had a heart attack," she said. "His name was Mr. Goodson, James Goodson, out of Titusville. The teachers said they had never seen anything like that in their lives. We felt bad for him because he was one of the best, but they had threatened him. They had threatened him."

The Children's Crusade was just the beginning of Williams's involvement with civil rights; in her senior year, as a member of a teen group called the Crusaders, she worked to educate people about the movement's objectives.

In college, she became president of Future Voters of America, a group that met at Miles College, a historically black university in nearby Fairfield, whose students and professors had been early proponents of civil rights protests. "We would go out in neighborhoods," she said, "and we would talk to people about the importance of voting. We went to basically all-black neighborhoods—Ensley, east Birmingham, the part of Tarrant that was black at that time and the part of Inglenook that was black. We went to Bessemer. We went everywhere."

That experience taught Williams that black citizens weren't the only ones who needed voter education and that there were still people in the community determined to restrict the civil rights of others.

> *Students would come from all over the United States. I had a friend from Oregon; his name was Carlton…he was a white guy. We had all kinds of people. African people would come, and we would sit and figure out things we needed to do, different strategies…We would go to different neighborhoods and oftentimes we were walking because we didn't have cars.*

Our people—Reverend Abraham Woods, he was over me—would drop us off. And it was, basically, how many people you could squeeze in the car.

Woods would drop them off, and the kids, working in pairs, would go to different homes.

"We even went to white people's homes—poor white people who did not know," Williams said. "They were happy we came to tell them about voting because we didn't turn around when we saw that they were white. And we would tell them, and a lot of them said they wouldn't have even known that they had the right to vote."

On more than one occasion, though, "rednecks would be in their cars and trucks and try to run us off the road, and we would have to run for our lives," Williams recalled. "Sometimes, we would run…into little black cafés that were owned by black people and then we would call…them to come pick us up. We felt we were in a lot of danger."

At age nineteen, she turned her attention to her education and the need to get a paying job. Williams became a seamstress and a tailor, an occupation she continued throughout her adult life. But what she learned in the movement never left her. As she raised her children, for example, Williams made sure they knew about civil rights and their history:

> *I talked about it because I wanted my children to understand that all of the privileges that they had, people made sacrifices for them to have. My daughter graduated from Stanford in California and got her masters there. I always wanted my children to go to black colleges first, so my son went to Alcorn State University. He received his undergrad and master's there. She went to Spelman College, and nobody understood. My son received a full scholarship at* [the University of] *Alabama, and he didn't take it, and nobody understood that.*
>
> *But when they are little, you have to teach them about who they are. When my daughter graduated college, we thought she was going into biology or pre-med because that's what she had planned to do.*
>
> *But she said, "Mama, you taught us history and I love my history." And that's why she is a history teacher today* [at Birmingham's Huffman High School].

When the opportunity arises, Williams also talks to other kids about the movement. "I prefer children. They ask a lot of questions. They can't believe a lot of what you're telling them."

She calls the activism she began in 1963, "one of the most important things that I've ever done. I thank God for it because it had to be Him who guided a sixteen-year-old out to demonstrate…There are some people who don't want to talk about it. They're not proud, but I am."

The nonviolence training she got in the movement, she said, continues to help her cope with difficult situations. But the spirit of rebelling against injustice makes her determined not to accept mistreatment:

> *I am more outspoken. Even on my jobs that I had, only God kept me with those jobs forever. Because once you go through that you become a different person. I believe in being verbal, and if something is wrong, I'm going to let you know it's wrong.*
>
> *That changed because of the movement. I don't believe in all the violence—you know, attacking people—but verbally, I will let you know that you crossed my path.*

Finally, she noted, the success of the Birmingham movement proves that change is possible if people work together: "The thing that people don't know—and I've taught my children this—one person can't turn things around, but a group of people…yes, you can."

CLIFTON CASEY

For several years now, since he retired from the railroad and moved back to Birmingham, Clifton Casey has been volunteering at the Birmingham Civil Rights Institute. Part of his volunteer duty involves telling his personal story of involvement in the civil rights movement during the 1963 Children's Crusade.

He was there, carrying a sign from Sixteenth Street Baptist Church to protest segregation. And yet, if you ask him about how his time in the movement began, Casey will shrug and say without hesitation, "By accident."

There were kids who grew up in Birmingham who felt compelled to join the movement because they had witnessed the injustice and were determined to do something about it. And there were some who—like Casey—just found themselves caught up in something big, something that took them far out of their comfort zone and, as it happened, into history.

"Honestly," he said, "I got involved in it because of following the crowd." The day he followed the crowd was the first day of the Children's Crusade, May 2, 1963, designated D-Day by movement organizers.

Even before that, though, it is not as if Casey was oblivious to what it meant to be discriminated against, or unaware of how dangerous Birmingham could be under segregation. An event that occurred in February 1963 makes that clear:

> *For my birthday, I got a transistor radio. It was a routine I had—I would lie in bed after I got my lessons done and listen. We had real good transmissions*

He volunteers at the Birmingham Civil Rights Institute today, but Clifton Casey says he fell into the fight against segregation "by accident."

at night. And this particular night, the transmission was really bad, so I got into bed, cut the radio off and there was this big explosion.

What happened was they had blown up the church next to my house on Twenty-fourth Street. We called it the Triumph Church. It was just a small church, nothing significant, but what we think happened was they were trying to get Shuttlesworth. But a lot of churches at that time had guards up and stuff, and they couldn't get him, so they started going after people's cars and smaller churches.

It was amazing. It blew off the dome—the dome was gone, and it was right on the side of our house. Nothing happened to our house. It didn't blow a window out, crack a wall or anything. It was pretty amazing, but nothing happened to our house. At that time, we were going to a Pentecostal church,

and they say God is in, you know, a flash of light or fire, and lightning and all that stuff being the power of God. So, I think it was a Higher Power.

That incident, however, was too much for Casey's older half sister, Ruth, who, along with her husband, was raising him, his brother and three other kids. They called her "Mom," Casey said. "Mom said, 'It's time to go.'" She left for Cincinnati, to close on a new home in late April of that year.

"And she said, 'Don't y'all get involved in anything when I'm gone, 'cause I don't want anything to happen, and I won't be here to help you if something happens.' And that was really my intent," Casey said. "Then I got to school, and everybody was talking 'bout they were going to leave at twelve o'clock to go demonstrate, and I followed the crowd."

In that crowd were kids prepared to make sacrifices for the movement. But Casey wasn't really fully aware of what was to come. "I had no intent of going to jail. I had no intent of getting involved. Some kids came to school with toothbrushes and toothpaste. I did not. It was the last thing I would think of, getting arrested and going to jail," he said.

He found himself at Sixteenth Street Baptist Church, listening to an orientation from James Bevel before the march. Bevel told them not to carry knives and to be determined not to fight back when confronted. He or someone else also told them, as Casey remembers it, not to give their names should they be arrested. "They said back then, if anybody got involved, their children even, they would take it out on the parents. They would get fired from off the jobs," Casey said. "We were self-employed, so I hadn't even thought about that."

The kids were lined up in pairs and given signs to carry to city hall. Casey fell in line with the rest of his senior class. "So we came out of the church—big crop of people out there—and we started marching down the street," he said.

I had a sign. I don't remember what that sign was saying, I'll tell you the truth. I'm being honest with you. I'm not trying to belittle the thing, but—you know, some people think I'm telling a big glorious story about how I was inspired by Dr. King, but at this particular time, I was not really involved in this. My father participated when he was living back in the early '50s. But I'd never been to mass meetings or nothing.

Casey said his family had been fortunate to find a way around some of the restrictions placed on African Americans in segregated Birmingham. They could easily travel north because his father had worked on the railroad:

Birmingham City Hall was the one of the major destinations for civil rights marchers during the 1963 Birmingham movement.

We saw two sides of the world. We saw the southern side and the northern side. And you can probably imagine how the northern side was different from the southern side. We had white friends that lived in Michigan, and we went to amusement parks and stuff with 'em, and the rule was, "Just wait until you get back to Ohio and do it."

I remember one time going out by Kiddieland [at the Alabama State Fairgrounds, a facility not open generally to black kids] *and, you know, "Let us go ride the rides." But* [his parents said], *"No—wait until you get back to Ohio." That's just the way it was.*

In many ways, Casey's family was firmly in the middle class, the group in the African American community that, by many accounts, took a less active role in protesting segregation. D-Day was Casey's first real involvement with the movement.

"I'd never been to a mass meeting or anything like that," Casey said. "That day, when I got on line, I was terrified! And then we walked down the street, and I saw the police, and I mean, I was totally petrified." He was walking alongside Annie Cunningham, whom he described as "my classmate" (she described him as her boyfriend), and they were carrying the same sign.

"And the police said, 'Give me the sign' or something. He tried to snatch it out of my hand, but she was just holding that sign," Casey said. "We were just that scared. That was the first time I had been approached by a policeman."

Why was Casey so scared? It takes a long digression to explain how Casey remembers police harassment as an everyday occurrence that left him with abject fear:

They use to chase people just for the fun of it or abuse people for really for no reason. Good example—there was a guy in the neighborhood, Lionel Davis was his name. We called him Cool Breeze. He went to Parker [High]*; he was supposed to have broken the* [record for the] *hundred-yard dash* [although the organization governing high school sports wouldn't give it to him]. *But he was fast. The cops would just chase him for the fun of seeing him run. They would see him on the porch or something, and they would just mash on the brakes, and if they caught him, they would beat him. Twice I witnessed this.*

Casey also told a story—to which many who had grown up under segregation attested—about Car 13, a Birmingham Police patrol car with the silhouette of a black cat attached to the trunk lid. The car regularly ran through black neighborhoods to intimidate people. "I saw it. It patrolled our neighborhood," Casey said.

His family had their own business, which also brought harassment from the law. "We had a little sandwich shop," Casey said. "We did pretty well with

it. And back then, a lot of these little black businesses, they sold moonshine on the side. The cops would pull up outside. They'd come inside, look in the refrigerator, look in the bathroom, wouldn't say a word. Just walk around the store. It was frightening."

And Casey recalled what happened to people he knew who committed the offense of walking down the streets of their neighborhoods at night and encountered one of Bull's officers.

"They catch you walking the street at night for no reason, they'd say, 'Come here…Where are you going? Put your head in the window. I can't hear you.' They would roll the window up on your head and beat your head with a rubber hose. That was a known fact."

The police of his youth were involved in petty, senseless violence, Casey remembered. "A domestic argument [occurred] in the neighborhood one day. Somebody called the police. You never tried to call the police for nothing," he said. "Police got there and got out of the car and said, 'What's going on here?' and just started hitting folks over the head with the blackjack.

"The police was somebody you were just totally fearful of. And then for me—my first confrontation—it was frightening."

During the protest, Casey was too scared to notice what his sign said and too scared to remember the freedom songs being sung around him. He got stopped a few blocks away from the church, on the way toward city hall. And although he was scared to death, he also noticed that the police seemed to be less than sure of themselves confronted with the hundreds of marching, singing children:

> *They were sitting there like they were trying to figure out, "What are we going to do with all these kids?" We were older, but some of them were younger. There were still a large amount of people.*
>
> *And Bull Connor pulled up in a car on this side, and he said, "Put 'em in the paddy wagon." They started bringing out paddy wagons and putting us in the paddy wagons. And Ann told me this…I ignored the fella, and he just pushed me in the door. I don't remember that. I'm sure she's telling the truth. But I was so afraid—that's the thing I remember about this thing.*

Casey's arrest was a part of movement leaders' strategy to fill up the jails in and around Birmingham, adding strain to a political and economic system already under assault by boycotts and pickets, which were designed to force concessions from segregationists. It worked; eventually, thousands

were jailed, and the protests led to a truce between the movement and representatives of the business community in particular.

At the time, Casey understood the overall stratagem from only a limited perspective—that of a teenager in jail:

> *My brother got put in the jail at the Fairgrounds and Bessemer. But the cell I was in—most people there—I knew them. I knew a lot of them. I was in the Birmingham Jail at first. We stayed, I don't know, two or three days or something, then they transferred us to the jail on Sixth Avenue. In fact, they hadn't even finished building it.*

Casey remained in jail until May 11, partly because he and many of the other kids who were arrested refused to give their names to the police—a safeguard for those parents whose jobs would have been endangered because their kids had become involved in the movement. So when his half sister came looking for him in jail after returning from Ohio, the police told her they didn't know exactly where he was and weren't going to look through all the "No comments" to find him.

For the first two days, Casey recalls, incarcerated in the jail on the top floor of Birmingham City Hall, they ate snacks they purchased from trustees. "The first meal they served was grits and pork and beans. The pork and beans, I remember, they were slimy," he said. "One of the guards hollered, 'You boys want some lemonade?' It was a pitcher of water." The food got better at the Sixth Avenue site. But it was still no place like home."

Casey remembers the conditions as being crowded, with more prisoners by far than the facilities were equipped to handle, and more than the law allowed. "There were so many of us in there, half of us had the bunks in the day time, and half had the bunks at night. I was fortunate that I had the bunk at night."

He was released about 4:00 p.m., nine days after his arrest. "They just came around one day and said, 'Y'all can go. Get your stuff.' They opened the door, and we just ran out in the street. By this time, the order [had come] down from [Attorney General Robert] Kennedy that they had to release us."

He got a ride home, and he remembers his half sister coming out the front door to greet him. "I think back now, and I feel sort of bad because of the torment I did on her," he said. "She was in Ohio. The way she knew we were in jail was she saw it on TV...Me and Mom, we never talked about it."

He learned later, after his half sister died, that while she was in Cincinnati, she had seen either him or his brother on national television being loaded

into a paddy wagon. Now he realizes, with myriad examples of black boys being killed by mysterious perpetrators—from Emmitt Till to a young murder victim in their own neighborhood—having her kids arrested and lost in the hands of the Birmingham Police had to be traumatic for her.

At the time it happened, though, Casey was more focused on how glad he was to be home. But he confesses—he might have been kidding when he said this—that he "walked around the house for six months scared to death" that Ruth was going to "get" him for getting into trouble. But that never happened.

Many civil rights movement protesters said that the experience profoundly changed their perspectives or at least shaped how they would view the world from then on. But Casey's reaction was more in line with the accidental way he became an activist.

"The way it affected me mostly—it's probably a good thing—that day I said, 'I will never do nothing to go to jail again.' And I have not."

Still, his time in the movement was not completely over. Although Casey's family moved to Cincinnati, someone in the NAACP there learned he had lived in Birmingham and had been jailed during the Children's Crusade. Soon, he found himself on his way to the March on Washington, telling people, reluctantly, what protesting in Birmingham had been like. "When I was in Washington, marching down the street, and I saw a bunch of police and army guys, you know what I did? *Got out of line.* Got on the sidewalk. I was not going to jail again."

In time, Casey lived a full life filled with happy accidents that led, among other things, from a railroad career to a citation in the air force to becoming an international tax accountant working for a company that allowed him to travel the world.

That ended up giving him a new perspective, both on how the civil rights movement in Birmingham is regarded in other countries and on his own part in it.

"I ended up being involved in something that I feel was probably the best thing that I've ever done in my life," he says.

> *But at the time, I didn't think it was such a wise decision. You look at the benefits now. You see kids now. Integration is here. You can get good employment. Brutality and racism is practically out the window. The Ku Klux Klans are gone, practically, for all theoretical purposes. I feel now that I was just a small part of something, and it took all of us to get it done.*

He remembers visiting Germany as a tourist in 1990:

> *I was shocked. They have a museum called Check Point Charlie...at the old gate. And it is primarily dedicated to the struggle they had of trying to break the Communist hold on East Germany. But on the upstairs, they had one big room that was totally dedicated to what happened in Birmingham in '63...Martin Luther King and what he did, the struggle and so forth. It's equated now with what Gandhi did. It set the pattern for something to be done and how to do it in a peaceful way.*

Casey now sees the Birmingham movement and the American civil rights struggles as inspiration to people fighting for human rights in other places across the globe. The success of the movement here, he says, encouraged other oppressed people to take a stand for their own freedom, eventually leading to the fall of the Soviet Union.

Many people in the world still don't enjoy the freedoms Americans take for granted, he said. And as the Hispanic population increases in this country, Casey sees that ethnic minority facing some of the same challenges—perhaps to a different degree—that motivated the protests in 1963. Casey is convinced, by his accidental experience, that with enough people behind a movement, things can change for the better. Seen from that angle, even those who just follow the crowd might have a part in something bigger than they know, he said.

"In D.C., the March on Washington, there were 250,000 people there. But what if everybody would have stayed home? It takes the masses to get something done, accomplished...I was just a small cog. It was meant for me to go to help fill the jails up."

ANNIE CUNNINGHAM SEWELL

Annie Sewell grew up in Birmingham's Collegeville neighborhood, just one street over from Bethel Baptist Church, whose pastor was Fred Shuttlesworth. This is how she got involved in the civil rights movement and why, to this day, Birmingham remains a bitter pill for her to swallow.

Shuttlesworth was a lightning rod, drawing together church members from all over the community, creating a network of like-minded churches and igniting a common passion against the injustices of segregation. Although young Annie Cunningham's family did not attend Bethel for purely religious reasons, they did attend mass meetings of the movement there.

"We would go over to Bethel, and we would listen to Fred Shuttlesworth talk, and then this idea came up that the children would be involved and go to jail so we could bankrupt Birmingham. We had already been boycotting the buses and the stores, so to me, that's what we should have been doing anyway, even though I was a kid," Sewell recalls.

> When they came up with the idea that they would send children to jail, some of Martin Luther King's foot soldiers came to various parts of the city and had meetings and talked to the kids. So I had been to a meeting at Sixteenth Street Baptist Church. I had been to a meeting because my mom was involved and she took us to these meetings.

Her mother, she says, got caught up in "a fever in the neighborhood" to participate in the civil rights movement:

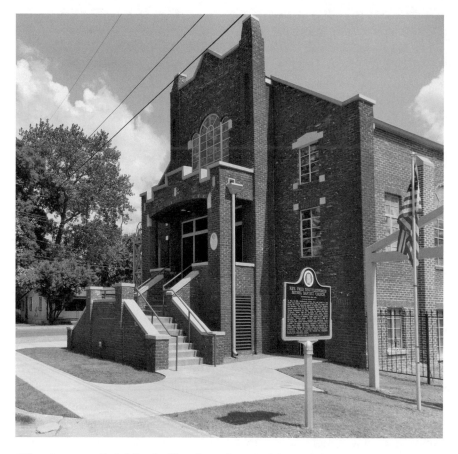

Although a newer Bethel Baptist Church stands around the block from this one, the church from which Shuttlesworth preached most forcefully against segregation remains as a legacy.

It was something about the leadership of Fred Shuttlesworth that just made the neighborhood a cohesive unit. And so, a lot of her friends were involved. And so, it was time. It did not make sense for us to be riding on the back of the bus and the bus was coming to our community. And they were putting that little wood block halfway up the bus...

I had this job for one of my friends who had had a baby, so she was trying to become an LPN, so she didn't want to lose her job working for this white lady. So I went to work for her so she wouldn't lose her job in case she didn't make it as an LPN.

So one day, coming from work, I was tired, so there was no white people on the bus, so I just moved that little placard and sat down, and it scared the heck out of the people. The bus just went silent, which made the driver

wonder what had happened. So he finally figured out after looking in the mirror that I had moved that little placard and sat down. So he stopped the bus, he came back and he was going to make me get up. I ignored him. But he didn't put his hands on me, he just told me, "Nigger you better get your ass up." So I just ignored him. Well, he started driving the bus and throwing these black folks around like nobody's business. And they kept telling me, "Get up, get up, get up."

She suspected the bus driver intended to wait until she tried to step out of the bus and then would deliberately close the doors on her in retribution for her defiant act. So when she got near the open door, she jumped out too quickly for the driver to react:

By the time I got home, my mother had heard what I had done. Somebody had called her and told her. And I think that that might have been the thing that really pushed her to get active because she figured that if I would take that kind of chance that she needed to do something.

The other thing that really motivated her to stay active was, when they were able to vote, they sent my mom a card, even though she passed the questions that they asked…she got this slip saying my grandparents passed but she didn't pass because she had two illegitimate children. And that, really, that was the icing on the cake.

When the civil rights leaders asked for her involvement, "there wasn't anything that she wasn't going to be willing to do."

Annie had also developed a defiant attitude toward the system that mandated segregation.

I had already drank out of the white fountain and discovered their water was no different. I had already been in their bathrooms, trying to see what was different about their bathrooms…

When they came up with the idea of us going to jail, we got excited.

Seventeen-year old Annie and her fifteen-year-old sister, Andrea, marched on the first day of the Children's Crusade—D-Day, May 2, 1963:

We went to the meeting for the children the night before. My mom took us. And they gave us our instructions and told us what to do, where to meet, what time to meet and all of that. Well, the threat had gone out that they

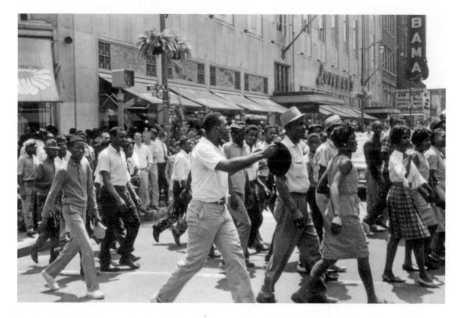

Leaders of the civil rights movement in Birmingham took the unprecedented step of involving children in the mass protest with devastating effectiveness. *Image courtesy of BCRI Archives.*

were going to expel us from school. So my mom said, "Well, you all are not going to school. If you don't go to school that day, they can't expel you 'cause you weren't there." So anyway, we didn't go to school, but my mom and my granddaddy dropped us off at the church at eleven thirty—we were supposed to start this demonstration around noon. My sister's boyfriend rode down with us. At the time, I considered [Clifton] Casey as my boyfriend. So we waited for him, and we were among the first group that kind of left Sixteenth Street.

Their orders were to march in pairs, and she was holding one side of a protest sign while Casey held the other. They marched, as she remembers it, across Kelly Ingram Park, diagonally across the street from the church, and were immediately arrested. The officers tried to take the sign away. Casey let go immediately. Annie tightened her grip. "I was holding on because they said, 'Hold on to your sign,'" she says, laughing at the memory. "And you know, I think it was probably more the devil in me, to aggravate them more so than following directions. I was probably being my rambunctious self."

As they were taken into custody, Casey got separated from the group:

Unfortunately for Casey, he was the last one they threw into the paddy wagon. And my sister and her boyfriend and me, they put us in a detective's car...

It was two big, burly white men. And one was smoking a cigar, and the smoke was coming back in my face. So I...was rolling down the window, asking him could I roll down the window. He said no, but I didn't roll the window back up...

That night, we first [were] *in the city jail, then they took us from the city jail to juvenile detention—there was no room—and about midnight we ended up in the county jail. And we stayed in the county jail in a cell that was supposed to house like three people. It had a day room, a hallway and three bunk beds. Those steel things. We were a bunch of girls in this cell. So you know, it was horrible. But on Saturday, they took us out of that place, and they took us to the state Fairgrounds because they were hiding us from Robert Kennedy, who came to check on the conditions of the children in jail. So we stayed at the Fairgrounds from Saturday morning until about Friday of the next week, about noon.*

There were about three thousand girls there, and my sister and I were like [among the] *thirteen and fourteen left. And my mother only came and got us then because my sister had serious cramps. So the matron called my mom and said they didn't have a way of taking care of my sister, so come and get us.*

Annie was in jail for nine and a half days. "I guess, as I look back on it, I thought it was a small price to pay for the outcome," she says.

After the movement, she went off to college, where she studied sociology and history. Still later, while she was visiting Atlanta for Martin Luther King's funeral, she decided to stay there and find employment. She worked first for Planned Parenthood and then for Traveler's Insurance before moving to Cleveland, where she worked for the Ohio state mental health authority, then had a job at Metro Health in Cleveland for thirty-three years as a psychiatric social worker.

Today, Sewell has mixed feelings about Birmingham. In the aftermath of the movement, she recognized a sense of pride in those who participated in the marches. "I think one of the things that stood out for people in Birmingham was the power of being united," she says. After the movement, public accommodations were integrated and some things changed.

But in her mind, the gains didn't outweigh the things that didn't change—or that didn't change enough—or the recollection of how things had been before. She remains bothered by how officials in Birmingham closed the public parks and recreation centers rather than integrating them:

> *I'm learning how to swim now because I never learned to swim because the parks were closed. So immediately, there was no changes like you would like to see, with jobs.*
>
> *I just felt like, yeah, we did what we did, we got voter rights, we could go where we wanted to go, but you can't go without money. So jobs didn't necessarily become more plentiful.*
>
> *Yeah, men worked at TCI, the steel mill, they worked at U.S. Pipe. My grandfather worked for the Frisco Railroad, he was a chef-cook. But he was a chef-cook before then. And I guess we were middle class. I didn't realize that then…We weren't doing anything.*

She speaks in the same vein about the fact that after the movement, students in black schools still had poor resources in comparison to white kids:

> *Students still had the throwaway books from white schools. I didn't learn to type because we didn't have any typewriters in my high school. The typewriters were in the office…A lot of things I think we should have had, after the fact, we didn't have. So when I came home from college, things looked like they were a bit better, but I don't have any desire to live in Birmingham today.*

Sewell even hates, she said, the accents of southerners and remains bitter today—and not just toward the segregationists. "I was really angry," she says,

> *at people who had children who were in a different, or thought they were in a different, economic level. They didn't let their children go to jail, but they were the first to enjoy the fruits of the labor. I think about people who were on my street who were teachers and what have you. Their children didn't go to jail, they didn't participate. But they were the first people to take advantage of going to restaurants and things like that. And they never thought about taking the kids that paid the price. That always just bothered me…I'm sure if this happened ever again they wouldn't feel they should have to pay the price. They just wait for the gravy.*

She says that at the time she didn't expect folks who were better off economically to participate in general. "But I thought the people that I knew who were on the street that we grew up on, I thought their heads were in the right place."

Sewell recalls how those same parents also didn't help her when she was preparing to go off to college. Her own mother was not in a position to help her, having a limited education herself and having worked as a maid for white homeowners in Mountain Brook and then as a cook in a daycare. The teachers who lived on the block, graduates of Alabama A&M—where Annie wanted to go and eventually did—did not assist her with her application. A white insurance salesman who came to Collegeville to sell and service insurance policies did. She still harbors some indignation about that.

And yet, for all her strongly negative feelings about Birmingham, Sewell does not regret her part in the city's civil rights movement.

"I would have never wanted change to happen without me," she says. "If I had to think of what I did in this world that was critical, I'd think that that was critical. I've done some things in my professional life. But just in my life, I think that was the most significant thing."

That time in Birmingham, that experience, helped define her values to this day:

> *When King made the speech in Washington, D.C., the "I Have a Dream" speech, even though buses left from Birmingham, my mother didn't let us go because she couldn't afford to go. And she said if we were arrested in D.C., that was too far for her to have to come to see about us. So we weren't able to go.*
>
> *But I always said that if they did anything again, to remember that day, I was going to be there. And when they did it this year* [September 2013], *I was there. I mean, it was important for me to be there.*

GERALD WREN

B y his own admission, Gerald Wren is a militant. That's militant as in "black militant," a term used in the 1960s and 1970s to refer mostly to those African American activists and political pundits who viewed taking action as a viable, appropriate means of wresting their freedom from systemic oppression.

Think Black Panthers instead of Southern Christian Leadership Conference. Think early Malcolm X instead of Martin Luther King.

Although he is nearly seventy now and certainly seems unlikely to advocate violence, Wren still sees things in terms of black resistance against white aggression and believes that the seeds for revolution among the oppressed minority—Hispanics in this case—are already being sown.

Wren is a tough man who lived through tough times. He's been a soldier and worked as a carpenter, a stonemason, a plumber and at two steel mills. He quotes the aging rhetoric of the black revolutionary to predict the future he expects and to point out that he still doesn't entirely trust white people:

> Stokely Carmichael said, "That peckerwood understands that match and that gas. And when you strike that match and throw that Molotov cocktail, he's gonna talk to you, 'cause they don't want their town to burn down." See that's what happened. When they start to put that rag in that glass and lighting and throwing it. See that Jew, he had the merchandise in town. Nobody shopping in his stores. You throw that Molotov cocktail in there…he'll tell those Europeans, "Y'all better talk to these folks"…They come to the table.

Gerald Wren was a "militant" when he joined the Birmingham movement, but he managed to remain nonviolent.

You ain't got to have no army. You stop that wheel from turning—the common people don't go to work. Sit down. It's gonna happen again in America. When these Hispanics—if they don't give them what they're supposed to have, they're gonna sit down again and its gonna stop the whole thing. They're the new niggers. I'm sorry to say it like that, but they are. See, we got too expensive for them. We wanted Blue Cross and Blue Shield just like they did…

Some might argue that Wren is a racist. But where he came from no doubt played a part in who he is.

Wren didn't grow up on the streets of Watts. He grew up on the streets of Birmingham's Smithfield neighborhood, and he, too, was a young foot soldier in the civil rights movement. While some of the movement's nonviolent soldiers came to believe completely in the path of brotherhood and today speak in kindly, respect-laden words about how walking with King and Shuttlesworth changed their lives, Wren still talks conflict.

That is despite the fact that he marched as peacefully as most in 1963, accepted the philosophy of nonviolence that was preached to protesters and faced down Bull Connor's "hose pipes," as he calls them, without retaliation. It is also true despite the fact that Wren went on, if reluctantly, to serve his country in Vietnam.

Not all foot soldiers are willing to share their thoughts about the movement, so who knows how many share at least some of Wren's views and suspicions? But the same crucible—segregated Birmingham—that produced peacemakers and teachers also produced Gerald Wren.

He was reluctant to tell me his story, he said. "I turned everybody down but you. I don't know why."

He must have told me that three or four times, the last when he was showing me around his house in the College Hills neighborhood in Birmingham, not far from where he grew up. Once he started talking, though, he had plenty to share.

Despite the segregation in the city, Wren had fond memories of growing up in Birmingham. "It was beautiful," he said. "The block I come up on—I mean, people talk about role models—we had plenty. There were eighteen of us on Fourth Street—eighteen boys. We had an architect, we had two doctors, we had a banker, all men that owned funeral homes—same two or three blocks. Teachers who taught at Parker [High] stayed in my neighborhood."

The neighborhood had good role models, but they didn't make as much of a good impression on young Wren as you might think. "Not on me," he said.

I was the black sheep of my whole family. I was the first one that went to jail. See, they were against me demonstrating.

My grandfather was a preacher, and he was against it because, he said, it wasn't time. I used to ask him, "When?" But he used to go from Birmingham to Chicago to see his daughters, and he had to stop on the side

of the road to pee. I said, "You ought to be tired of doing that, Reverend." I said, "You need to be in line with us, demonstrating for your rights. I know you get tired of going to that back door, too."

"I was a militant," Wren said. "I was more militant than the rest of the people in my family."

That "militancy" might have been seen initially as something else: as the rebellious nature of the sick and tired gang of teenaged jocks he hung out with. Rebellion was certainly one of the earliest ways Wren expressed his displeasure toward the system of white privilege that pervaded Birmingham.

About his seventeen closest friends, he said:

We just integrated everything. All of us just about played sports. Anybody playing football, basketball, baseball. On our street there were kids six-four, six-six, 270. They were big boys. And you know how Caucasians look at big boys. They get scared. So we would get on that bus, and everybody would get a seat. Make them sit down by you.

They refused to give up their seats for whites. "We used to make them stand up." That bold action was not without consequences, Wren admits. The bus driver would pull off to the side of the road and call the police. "You had to run, man," Wren said. "You had to get off the bus before the police get to coming cause they gonna put you in jail or beat you up, one."

Wren said that he and his friends also armed themselves and acted as guards in the neighborhood, especially after attorney Arthur Shores's house was bombed by Klansmen, which happened twice in 1963. Birmingham, to help put that bombing in context, was the site of almost fifty "unsolved" Klan bombings directed mostly at black homes and churches that started in 1947 with an explosive device set to prevent a black man from buying a house in North Smithfield, according to the BhamWiki website.

By the time Wren and his friends joined the guards in their neighborhood, the city was being called "Bombingham" by many African American residents, and Smithfield in particular had a section known to this day as "Dynamite Hill."

"We used to have to watch Shores's house," Wren said. "We used to walk shotgun. After they bombed his house, we had to guard the neighborhood. Every time the bombings was done, the police knew who did it. Some of them was Ku Klux too. When he knows you're walking guard with that shotgun, he ain't coming down there to you. He don't want to die."

Still, neither militancy nor simple defiance drove Wren into the movement. There was also the church, and the girls, he said:

> *We used to fellowship. I'll tell you who used to fellowship: Trinity, St. Paul, Peace Baptist, we used to all fellowship. BYU meetings—that's where all the girls used to be. And then, you know, Vacation Bible School, all the kids went to that, 'cause that's where they were serving cookies and lemonade and all that. That's why we got in the movement, because we liked to hear the singing and that was just something to do.*
>
> *And then, you know, we got tired of going in that back door, too.*

Outside the "beauty" of his neighborhood, life in Birmingham had another side, Wren said. "Birmingham was treacherous." And he saw one man as particularly exemplifying that spirit: "Bull Connor was the law. It didn't make no difference what nobody else said."

Getting involved in the Birmingham movement, particularly during that tumultuous spring and summer of 1963, meant—even for one with militant leanings—taking hold of the nonviolent philosophy at the core of what King, Shuttlesworth, Abernathy and others were trying to do. They were determined to break the hold of segregation with nonviolent resistance to the status quo.

Wren bought into it.

"See," he explained to me,

> *you had to be able to absorb that spit, or that kick. You see what I'm saying? The oldest is going to be in the front, and the oldest is going to be in the back; the youngest people gonna be in the middle. But you can't hit that fella if he spits on you because you got people behind you that are gonna get hurt. That's why they tell you, "You got any knives? Leave 'em. Put it in the basket. You can't be carrying no arms because it's nonviolent. You don't want that. Because it's a nonviolent thing. You can't stand to get spit on, don't get in the line. If you can't get slapped, don't get in this line." So that eliminated a lot of people. Some of them (would) get halfway and get out* [of the line].

Wren said he demonstrated a certain facility for remaining nonviolent and on task—to a point. He spoke of going more than once down to Newberry's department store to perform sit-ins at the notoriously segregated lunch counter. The job was to sit quietly and ignore the demands of the workers to

get up and leave. He said he would leave only when he knew the police were on the way. But in that interval, there was the danger of something testing his commitment to nonviolence:

> *When they see the police coming, the other people in the store, they get brave, then, and they go to hitting you and spitting on you. The customers.* The people. *The police don't be hitting you. It* [would] *be the customers. They'd stand by and let them do it.*
>
> *You'd have to be cool. You might get beat to death if you go to raring up. You* [were] *outnumbered.*

Despite that, he managed to visit Newberry's counter several times, he said, mostly without trouble. But Newberry's was also his destination the day he got arrested.

"That was the day when everything broke loose," he said. "That's the first day they brought the hose pipes out."

He showed me a photograph in a calendar produced by the Metro Birmingham Branch of the NAACP for 2013. Titled "When We Walk," the calendar showed a substantial but partial list of those arrested in the 1963 demonstrations, including Wren, and several vintage photographs, including one Wren said was made on Birmingham's Seventeenth Street between Fourth and Fifth Avenues.

There in the photo, taken near a place called Irene's Beauty Shop, is Wren, against a storefront, a short distance away from a young girl in bobby socks being blasted by a water cannon. Shortly before the photo was made, Wren said, he had been sheltering behind a telephone booth. "I was behind a phone booth at first, but that water pressure was knocking that phone booth down. I had to move."

He also appeared, he said, in an image that once ran in *Ebony* magazine, this time showing kids demonstrating in Kelly Ingram Park, directly across from Sixteenth Street Baptist Church.

The events of that day had begun for Wren and many others at Smithfield's Parker High School.

Students during what was known as the Children's Crusade had prearranged signals indicating when to leave their schools and head downtown for the mass protests. The principal at Parker, Wren said, tried to stop students from leaving. "They blocked all the gates, blocked all the doors," he said. Wren was among several students standing atop a fire pit to encourage fellow students to leave. The principal stood in the doorway

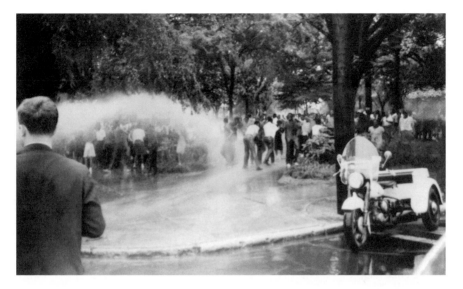

Bull Connor's tactic of turning fire hoses on peaceful demonstrators gave Birmingham and a U.S. government preaching democracy elsewhere in the world a public relations problem. *Image courtesy of BCRI Archives.*

with his arms folded to tell the students to go back to class. "We said, 'We're going.' I said, 'Let's go!' And he heard me say that. They said I was inciting a riot."

The Parker students left and joined students from other Birmingham high schools who also walked en masse down to Sixteenth Street Baptist Church. The strategy of movement leaders required a lot of kids if it was going to work, Wren said:

> *You couldn't fill the jails up with grown folks—they had to work. Fill it up with children. They sent the young people to the schools, every high school in Birmingham. They sent somebody with that loudspeaker to get them out of there. "You come out here. Ullman [High is] already in the park... What you waiting for?"*
>
> *Here they come. Then you just march in a whole line from Parker all the way downtown. Whole line from Ullman. They walking, walking downtown, walking to Sixteenth Street Baptist Church. Everybody see the children walking. Then they come by the elementary school, go in there and get their sister. People don't say nothing. They know its time. Done been time. You cannot stop no people's revolution.*

Members of the Southern Christian Leadership Conference and the Alabama Christian Movement for Human Rights joined forces and planned strategy in the A.G. Gaston Motel.

After getting organized at the church and being reminded about practicing nonviolence, the demonstrators deployed toward their downtown targets. "We had left out the church, went to the park. [The police] told us to go back in the church. We didn't go back in the church," Wren said. "We kept on uptown. We were going uptown to sit in. They wanted us to go back to Sixteenth Street Baptist Church. We wouldn't go back in there. So then they brought the dogs out and the hose pipes and started spraying us."

Wren got arrested and put in jail. Being seventeen, he was booked. He was incarcerated with comedian Dick Gregory, who had come to Birmingham to support the movement. "My daddy came to get me," Wren said.

> *I wouldn't go...We gambled the first three nights. We gambled all night. Dick Gregory—he had a stack of hundred-dollar bills like that—couldn't hardly fold them.*
>
> *We were in a big old cell—room 4102. I never will forget it. Big old cell. Everybody out. Ain't no bunks on the side, just a big old bay. You in there. I didn't take no shower. The only thing I did them seven days was wash my face. I had a pair of green Sansabelt pants on. I come out there, they were like these shoes. They were black. Nasty. All around my pocket was greasy.*

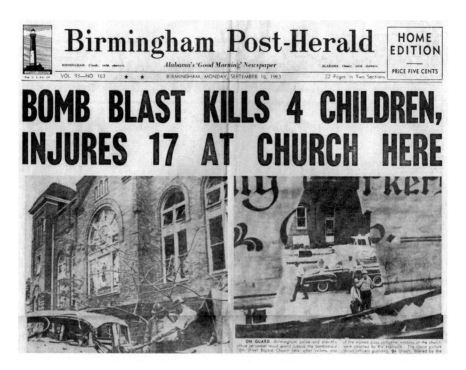

The headline of the *Birmingham Post-Herald* conveys the brutality of the Klan after the Sixteenth Street Baptist Church bombing claimed the lives of four young girls. *Image courtesy of the Birmingham Public Library Archives.*

Overloading the jails eventually helped bring Birmingham merchants to the table with the movement leaders, leading to an end to the protests of the Birmingham campaign. Wren was kicked out of school, he said, or would have been but for the intervention of sympathetic teachers. "Teachers who stayed on my street—they went to bat for me."

Wren was one of several bystanders in the crowd in the aftermath of the Sixteenth Street Baptist Church bombing on September 15, 1963, he said. "Knocked me and my brother out of bed. Bomb went off. I hit the floor. It was that powerful. Jumped up and went down there. They had it cordoned off." The four little girls killed in the bombing were all from families he knew.

And he remained involved in human rights issues for a time. For instance, he said, he went on to other civil rights protests in other cities. He rode with friends to Montgomery, for example, to add mass to the protest of the city's segregated public libraries. He had seen how the common cause of civil rights could bring people together in the early part of '63. "People came from everywhere to demonstrate. People came from Minnesota," he

said. "They sent twenty girls from the University of Minnesota down…They came from Boston, Connecticut" and several other places.

But by the time he left Birmingham for Tuskegee University, his feelings of militancy had intensified. Wren cited one example: how he reacted when he found out he had been drafted to serve in Vietnam (which resulted partly because he had stopped attending classes at Tuskegee).

Birmingham and what he had been through there still stuck in his craw.

"I just got through going through these changes in Birmingham, now you want me to go fight for you?" he said, describing his attitude. "I was just like [H.] Rap Brown or Stokely Carmichael: 'You the devil. You want me to go in the back door and yet and still you want me to go get that gun and fight? That man ain't did nothing to me.'"

He said he tried to avoid military service by talking and acting crazy. That didn't work. His Birmingham arrest record, stemming from the 1963 demonstrations, came up more than once. But that also did not get him out of the service.

Interestingly, although the army took Wren away from Birmingham, when he got out, he went back to live there, where today he rails against black people giving their hard-earned money to white doctors whom he maintains don't want to touch them and to Asian nail salons where the beauticians are talking about their clients in a tongue they don't understand.

And despite what he went through in Birmingham, Wren chose to work and retire there and to continue to watch what might be ethnic revolutions developing through news broadcasts he filters through his particularly Afrocentric perspective—a perspective that was shaped there.

RAYMOND GOOLSBY

Ray Goolsby is a friendly, polite man who loves talking about his time in the civil rights movement and how it taught him valuable lessons about opportunity. He has shared his story generously with visitors to the Birmingham Civil Rights Institute, including journalists from Switzerland, travelers from Belgium and groups from throughout the United States.

Sitting in his apartment overlooking Birmingham's Kelly Ingram Park, Raymond Goolsby, sixty-six, has a view every day of where history was made. Kelly Ingram Park, across the street from the Sixteenth Street Baptist Church, is a monument to the Birmingham civil rights movement of 1963 and is filled with sculptures and markers paying tribute to the men, women and children who made Birmingham's massive demonstrations happen. There is a monument to the foot soldiers, those ordinary Birmingham residents who got involved in the defiant movement to remove segregation because it just made sense.

It is a monument to people like Goolsby.

Growing up first in Kingston, east of downtown, and then in Titusville, a neighborhood a few miles to the southwest of the city center, Goolsby knew the Birmingham of his youth as a place of stark contrasts. It was certainly not all bad, even under segregation.

"When the housing project came through Kingston, we moved to Titusville in 1956, and I thought we were rich," he recalls.

Ray Goolsby was just a boy when the unfairness of segregated recreational facilities made him ask questions and join the civil rights movement. *Image courtesy of Raymond Goolsby.*

We had a new home, my sisters and I...Being in the middle of two girls, I had a good experience. My parents worked hard. My dad worked for the Railway Express up at the Terminal Station. My mother was a presser at McCain Manufacturing Company, and so, I mean, I can say that I thought we had a good life.

I got the English bikes, I got the Hutch football set, I got the trumpet to be in the band. My parents worked real hard and tried to supply us with our needs. I thought we were rich, one while. But my mom said, "Boy, you're way off target."

At first, he didn't fully understand how far off target his perception of life in Birmingham actually was. That's because his parents made a point of giving their children experiences that not all African American kids could have at that time:

My dad would get passes for us to ride the train, and we'd go up the East Coast all the way up to New York. We would take the train to Chicago. So we traveled, you know? And we would go downtown on Christmas and look in the window at Loveman's and Pizitz [two Birmingham department stores]. We always got something for Christmas. So all was good.

Despite living a peaceful, happy life at home, though, it began to dawn on young Ray that there was an inherent unfairness in Birmingham:

What really opened my eyes, when we moved to Titusville, we would have something they called May Day. End of the school year [at Center Street School], *they'd have a big picnic. And we would go past Kiddieland Park*

on Third Avenue West, which is now the Crossplex [at the Alabama State Fairgrounds], *and I would say, "Dad, how come I can't go in there?" It was a Ferris wheel and the train and the bumper cars, and dad would say, "Well, one day you will"—like that.*

So we would go out to George Washington Carver Park out in Bessemer [a city about fourteen miles southwest of Birmingham], *and there were two rides: a swing, time you got in, and a train that would go across a real dusty field. But mom would fix us tuna sandwiches and stuff, and we had a pop or something, and we'd have a good time. But it still remained in my mind, "Why can't I go in there?" and Dad would just say, "One day you will."*

We would get on the bus sometime, pay our fare, and we would have to go open the back door to get on, you know. And…as I grew older, I'd say, "Something just ain't right here, you know?" I remember the board. You know, you'd be sitting down, and a white person would get on, and if the bus was full, they would move the board back, and we'd have to get up and stand in the back. And I'd say, "Something just ain't right here."

It became, for young Ray, a familiar refrain and a recurring pattern:

Mother would take us, Christmastime, to downtown, and we would go down in the basement [of department stores] *to eat our sandwiches. I would look at the water fountains, and they would say, "White men," "White women," "Colored." It was like the "white" coolers were real tall where you didn't have to do nothing but lean over. But when you got to the "colored," it was a little pipe that went down, and we would get the overflow of their water. And we would be almost in the kneeling position to drink water. And I'd say, "Something just ain't right. Something just ain't right."*

By the time he became a junior at Ullman High School, Ray was going to movement meetings with his buddies George Stewart and James Hunter. "One guy had an old hooptie car, so we rode to the meetings, and we started seeing what I was thinking. It just modified that—that 'you're not being treated right,' you know? We would go every Monday night to the movement meetings, and that's when the bombings would come on," Goolsby recalls. At the time, Birmingham had dozens of "unsolved" Klan-perpetrated bombings, primarily in black neighborhoods. Those

bombings shook Ray Goolsby's view of the world and quite literally rocked his neighborhood:

> *There was bombings, bombings, bombings. My sister and I would wonder, who could it be this time? They just bombed lawyer* [Arthur] *Shores last week. They just bombed Shuttlesworth two weeks ago. Who is it this time?*
>
> *One night, a bomb went off right there on Center Street and Sixth Avenue South, right there by the Birmingham Library, the Titusville Library…One went off—this had to be around midnight. Bomb went off, and about ten minutes later another one went off in the same area and had shrapnel in it. So that bomb was intended to draw people and then* boom!*—devastation on that next bomb.*

But that time, the tactic—still used by terrorists today—didn't work. "Nobody came out," Goolsby says. "Nobody came to see about it. Nobody ran to it like we always would flock to it…I will never forget that. Nobody got hurt. Nobody came out."

The repeated bombings, which the police seemed unmotivated to solve (many of the Klansmen were in or associated with the Birmingham Police Department), earned the city the nickname "Bombingham" for a time, especially in the African American community where the explosives were directed. The attacks also prompted vigilance in young Ray's neighborhood.

"The men of our community started sitting in driveways watching," he remembers. "My father would get off work, and he would run a shift until daybreak. We had men rotating in our community. So at that time, I said, 'That's strong. That's unity. That's strength.'"

Still, many of the adults were limited in what they could do to change things in the city. For many, participation in the public demonstrations could mean unemployment. "A lot of our parents and teachers and people of this sort could not, they would not, participate because they would be harassed or lose their jobs or get fined or whatever if they [their employers] saw them on TV," Goolsby recalls.

On May 2, 1963, designated as D-Day, the start of the Children's Crusade, Ray Goolsby was one of hundreds of students who took to the streets as part of the organized campaign. But first they had to get out of school.

He said his teachers, including Cleopatra Goree, knew their students were planning to cut school and march in the demonstrations. "She turned her back, and we went on out. Left Ullman High School, walked out through the gate," Goolsby says.

"We left Ullman High School in my buddy's hooptie," Goolsby recalls.

I was still kind of wishy-washy, pessimistic about going…I didn't know what the outcome might be. They said "Don't be afraid to get arrested." I'd never been arrested—a sixteen-year-old kid going to jail.

But we went into this room in Sixteenth Street Church, and Dr. King came and stood right beside me… I had reservations at first, but when I met Dr. King and he prayed for us, I had no doubt in my mind that I was doing the right thing.

Organizers made the kids ready for their assigned roles:

My group was the first group, the first fifty of us, the first group out of Sixteenth Street Baptist Church. We made it to the AT&T building, which is a block and a half away. And our job was to decoy the police so the others could come around Third Avenue, Second Avenue and make it downtown to Newberry's, Woolworths. And so, mission accomplished…

When they stopped us, they said, "You got two minutes to disburse."

But a young woman in their group spoke up. "She said, 'We're not going.' And we knelt down, and when we knelt down, they picked us up and packed us in that paddy wagon. I heard on the radio, 'We got some more going around on the other side.' And they made it down there."

The first group of children, though, were thrown into the paddy wagon. "We stayed in jail five days," Goolsby remembers.

During the days they were there, more and more children would gather at the church only to spill out, tax Bull Connor's efforts to the limit and brave growling German shepherds, the powerful force of water cannons and arrest. The Children's Crusade, the most effective salvo fired by the civil rights organization, went on for days and led to a truce between city business leaders and the leaders of the demonstrations, including King and Shuttlesworth.

Meanwhile, the first group of children arrested in the crusade was becoming part of the historical record. "We were processed, fingerprinted, mug shots," Goolsby remembers. "They asked us, 'Who told you to march?' And they [had] always told us, say, 'No comment, no comment, no comment.' And the interviewer looked at me and said, 'Nigger, you got no-comment-itis. Get out of here!'"

If the elder Goolsbys were worried about their son, they were proud of him, too. "They allowed me to call my folks that night," Goolsby recalls.

"I called my mother, and she said, 'I know where you are. I saw you on Channel 6. Are you all right?' I told her 'Yes, ma'am, I'm all right.'"

While they were in jail, he notes, the young demonstrators kept up a spiritual program:

> *We were in a big old room. We always had service. What I mean is A.D. King* [brother of Martin Luther King, and pastor of First Baptist Church in Ensley] *came and preached one night and two or three other ministers. So they always tried to keep it in a religious type…prayed and tried to keep you upbeat about what was going on.*

The initial group of child crusaders got jail records, the charge being "parading without a permit." It was the same charge, incidentally, that

As an adult, Ray Goolsby shares the wisdom he gained during the movement with school kids and visitors to the Civil Rights Institute from around the world.

would bring King back to Birmingham in 1967 to serve a second stint in jail. But in 2009, Birmingham mayor Larry Langford (before he was removed from office and imprisoned on federal charges), gave pardons to Goolsby and the others who were arrested that day in 1963.

As Goolsby looks back on his experience now, his participation in the movement was a means of accomplishing what his father said: "One day you will." The movement ultimately gave him access to that which had previously been denied him. More than just a visit to Kiddieland, what Ray Goolsby wanted was opportunity.

He recalls a 1969 James Brown song that summed up how he felt. The song was called "I Don't Want Nobody to Give Me Nothing (Open Up the Door, I'll Get It Myself)."

"And that's what I always was just asking for. We were always told, 'All you want is a chance, an opportunity to compete, for whatever.'"

In his career, Goolsby took opportunity after opportunity; with a degree in data processing, he became a telephone installer—almost unheard of in Birmingham at the time. He subsequently worked his way up through various positions at companies such as Southern Natural Gas, Blue Cross/Blue Shield of Alabama, the University of Alabama–Birmingham, the *Atlanta Journal-Constitution* and the City of Atlanta. He became a senior computer operator and shift supervisor.

Retired now, Goolsby spends his time feeding the homeless through five different community agencies. "My thing now is just letting guys know there's still hope, there's still people that care. We are our brother's keeper," he says.

And he devotes his efforts as well to sharing other lessons he took away from the movement—lessons about self-respect:

> *I always tell kids who I speak with, "How are you going to know where you want to go unless you know where you been?"...There's been the big thing now with Trayvon Martin. But there have been a lot of Trayvon Martins. We got to learn how to respect ourselves. That's what I preach to people. It's not so much about civil rights...We got to be able to treat our brothers, together, right, you know?*

TERRY COLLINS

At sixty-five, Terry Collins is vice-president of the Metro Birmingham Branch of the NAACP. Even as he works to gather stories in the organization's Foot Soldier Finder project, it turns out that he is a foot soldier himself.

Terry Collins's involvement in the Birmingham civil rights movement was a natural progression from the things he had seen and the way his parents reacted to them.

"My parents, first of all, attended a number of the movement meetings, and in fact, many times the movement met at my church, Forty-sixth Street Baptist Church. In fact, that's where the movement choir originated. And Mamie Brown and Edward Gay…got together and organized the movement choir now known as the Carlton Reese Memorial Choir," says Collins, sitting at his desk at the NAACP office.

"After having gone to these meetings with my dad, he actually bought me a membership in the NAACP," Collins recalls. "Even as a little kid, it was being instilled in me to be an activist."

Even when the mass meetings were not held at his church, the young activist and his parents would attend, following the movement around town. "Whenever my dad wasn't working, we were at the meetings, so early in the game I got a chance to hear Reverend Shuttlesworth, Reverend Gardner and, eventually, Dr. Martin Luther King. And it was just so inspiring."

His father ran a grocery store that became a café and entertainment center—for black customers, of course—in east Birmingham, eventually known as Charlie's Place:

Besides being a veteran of the movement, Terry Collins uses his role in the NAACP to advocate for human rights causes.

Actually, it was next door to our house, and people from Alabama By-Products where my dad worked, a lot of those people and people from all over the city came there for entertainment and to socialize and eat. We actually had a jukebox, and eventually it got to the point where we had bands come in. It was quite an entertainment center.

But such a business also attracted quite a bit of attention from the police:

Anywhere black people congregated, the police would find their way there. So I had a little bit of experience seeing my dad have to deal with the police and seeing them, how they would interact with people as they would go and come, especially if they had something to drink—my father sold beer and all of that. So I got to hear a lot about what the police were doing around the community.

At times, he saw the police pull his father over—just, apparently, to give him a hard time. "I can just recall instances where my dad would be just stopped by the police," he said, "and I am, of course, sitting in the back seat listening to him. And I could tell that he was totally intimidated because this man has the power of life and death."

In the area of town where the Collins family lived, there was a particular police officer known for his determination to harass people of color. "There was a police officer who used to frequent the neighborhood," Collins says.

He had a black cat on the trunk of his car, and he wore black leather gloves, and he was known for slapping people. It was that kind of intimidation that you had on a daily basis. You've got a black cat carved out of cardboard sitting on the back of a police car…And it was so much of this stuff that it would sometimes leave you with a feeling of helplessness. I mean, what could you do? I mean the guys had guns, and the law, behind them.

Away from Birmingham, but still in the South, Collins saw other things that intensified and added new layers to the effects of the oppression he felt. "My dad also took us on family trips so we encountered, particularly in Mississippi, we encountered all kinds of state troopers," he remembers.

I even went on a bus trip with another church, Forty-fifth Street Baptist Church, where we went to Atlanta on a Saturday, a bus full of kids.

And on our return from Atlanta—we were on Highway 78 because there was not an expressway like there is now—we stopped at a gas station to buy refreshments. A pickup truck with white people and shotguns came by, and they shot up in the air and ran us away from the place—obviously just because we were black. I was much younger than fourteen when this happened, so this gave me a lot of experience interacting with people of this sort.

So when the talk came about marching, I was ready. You know, I had seen enough.

He was hardly alone in a city so strictly segregated, where institutionalized racism foisted similar indignities on dozens of Terry Collinses week after week. They were primed for the Children's Crusade:

Of course, I had no idea how many would do it. But after having gone to numerous meetings talking about "Now's the time for us to take action" and "Now's the time for us to stop being abused," I was ready.

Kids were talking about it because we knew the day was coming when we were going to be leaving the school, so word came down that now is the time to go. So I, along with hundreds of kids, walked back off the campus. I was a freshman at Carver [High School] at that point. We rode the bus downtown, and the rest of it is history.

Children from across Birmingham converged on Sixteenth Street Baptist Church. "We were upstairs as well as in the basement of the church because there were so many of us that we couldn't all get in the sanctuary of the church," Collins remembers.

The first thing we heard was the indoctrination about nonviolence, telling us that if we could not be nonviolent, then you couldn't be in this with us. Actually, it wasn't that hard for me because I wasn't the type of kid who got into a lot of fights and things, but on the other hand, I am one of those people who would defend myself. I really didn't think that I would be one of those individuals to be confronted because I would be in and among the kids. So, fortunately, I didn't have to end up dealing with that.

We were told to bring a toothbrush and a wash towel—a face towel—so that was what I took to school that day, to have in my pocket during the children's march. I was ready to go. Of course, I had never been to jail, so I didn't know what that was like, but I was prepared to do whatever was necessary.

The drama of the moment was palpable, Collins remembers. Having fellow students, just as fed up and just as ready, "was part of the excitement and encouragement."

Many of the kids at the mass meeting came with at least one parent, but a lot of them came on their own, Collins recalls.

Of course traveling to different churches and seeing different faces, you could get a feel for how fast the movement was spreading and growing all over the place. And when it was time to leave school, to see so many kids walking out with you, it wasn't like five or six people leaving. It was like hundreds of people leaving school. You know, it was like school was out. None of my teachers even addressed it. They just saw us and didn't try to stop us.

At the church, the demonstrators were divided into groups, "and then it was decided that the groups would go in different directions. There was a group leader with us. Leading our group, in fact, one of the guys that I

remember, his name was Hosea Williams. They would reinforce the things that Dr. King had told them."

Collins remembers making his way successfully to the downtown department stores and actually sitting at the segregated lunch counters at Newberry's, Kress and Woolworth "and having all those other people with me, of course. And of course, white people were in a panic."

Collins says he continued to demonstrate in subsequent days and, for his trouble, experienced being hit with powerful jets of water from the Birmingham Fire Department's high-powered hoses:

> *The attacks happened right below where Green Acres* [a popular restaurant of longstanding in the black community on Fourth Avenue North in Birmingham] *is. There was a pole there that I used to hold on to as the water went up and down my back trying to push us down the street. At this point, it was kind of scary, and I can't say that I really remember how it felt other than it was very forceful—you can probably find people who can be more descriptive with that—but I had to hold on for dear life not to be washed down the street.*

For Collins, the water hoses were the worst of it. As he looks back now, he counts his blessings:

> *I guess I was a little disappointed that I didn't get arrested because I was there and ready to go. But they* [police] *just got to a point where they just stopped. The water stopped, and everything just sort of came to a standstill, but it went on for hours or it felt like the confrontation went on.*

His parents, who had taken him to mass meetings, "were aware of what I was doing and were very supportive," Collins says.

> *They were all for it, and they couldn't do it for themselves. So Dr. King and the others had decided—it was time to use the children. And we were ready, willing and able because even the incident with the fire hose—it was dangerous, it was exciting, but being wet down with a fire hose wasn't a big deal. Of course, sometimes people got hurt. But still, it wasn't like being shot or being bit by a dog or being hit by a billy club, and all of those things were happening to people during that same period of time.*

The thousands of children who were arrested during the Children's Crusade overwhelmed the detention facilities and were a major impetus toward the city's economic leaders seeking a truce with black leaders.

"There was a feeling of pride. There was a feeling of accomplishment—especially when we heard that there were going to be meetings to make concessions. We felt like it had all been worthwhile."

After participating in the Birmingham movement, Collins went for a time to Morehouse College in Atlanta, where he met the activist Stokely Carmichael. Eventually, though, he returned to Birmingham and began to attend the University of Alabama to study engineering. And in 1969, he was appointed to the staff of Birmingham's mayor, Republican George Seibels.

"I was the first black—that I know of—to work in city hall and certainly the first to work on the administration staff in the mayor's office," he says. "I was assistant to the mayor. I did everything from carrying messages from the mayor to different departments, following up on them and taking responses back."

The job entailed Collins doing something that would have been unthinkable just six years earlier: representing the mayor's office of the city of Birmingham at events in schools, including his alma mater Carver High and Lawson State Junior College.

If that's not surprising enough, Collins, rising from his NAACP desk, walks over and points to a photograph of himself wearing an Afro and sitting behind a desk at his office in city hall. The surprise involves the furniture and a revelation by the photographer who shot the image.

"I was told when I first got to the mayor's office to just go downstairs and pick me out a chair," Collins says.

> *And there was this room full of nothing but chairs. I was told to "just pick out whatever you like." So I saw this chair, and I rolled it back upstairs, and so I'd been sitting in it for a while and [Bill] Ricker [who shot the picture] came by, and he said, "Terry, I see you selected a chair. Do you happen to know whose chair that is you're sitting in?" I said, "No, why would I know? It's just a chair. You said, 'Just go pick one out,' and I did. Hey, I know how to follow instructions."*
>
> *He said, "Well, that chair used to belong to Bull Connor." Now that's some heck of irony. Because just six years earlier, I'm outside protesting against a government and Bull Conner is still sitting in this chair, and now here I am, and I've got his chair.*

Terry Collins went from being a youngster protesting regular police harassment to working in the office of Birmingham's mayor after segregation. *Image by Bill Ricker, courtesy of Terry Collins.*

Is that a true story? Terry Collins says that it is. And as improbable as it might seem, it's the kind of story some of us would like to believe. But of course, Collins has long since left that chair behind.

Today, as he sits in his chair at the NAACP office, he is convinced of the power of "telling the story," which he does by talking with kids who weren't around when the events of 1963 happened. That's also what he's doing as his organization continues its efforts to find foot soldiers who have not told their stories and therefore haven't had the chance to connect with many of those masses who shared their experiences.

"I don't even know the name of the person who was standing beside me when the hose was being fired upon me," Collins notes. "All you know is that there was another body—another person with the same convictions…You both want to change things, and you were both there together."

CHARLES AVERY

Funny how things happen. It wasn't until I started working on this book that I realized I had met this bonafide foot soldier when I was a teenager. I probably was just not paying attention at the time. If I had been, I might have known how his experience in the Birmingham civil rights movement had an impact on my own family.

At eighteen, growing up just east of Birmingham in Ketona, an unincorporated part of Jefferson County near the small city of Tarrant, Charles Avery thought that the 1963 civil rights demonstrations that had engaged students in other schools might be out of his reach. After all, most of the kids marching downtown had come from Birmingham schools, and he was attending Hooper City High—nearby but part of the county school system.

Still, it wasn't as if Avery didn't understand the struggle.

"Tarrant City was the last municipality in Jefferson County to integrate—if that tells you anything about where we grew up," Avery says, smiling in his living room in the eastern part of town. "We knew the Ku Klux. We knew the police led the Ku Klux. We knew the whole story. We grew up running from the Ku Klux."

That experience shaped his interest in the civil rights movement and his initial reluctance to actually get into the fight. His father worked for American Cast Iron Pipe Company, commonly known, even today, as ACIPCO:

If you were a laborer in Jefferson County, you could be fired on the spot if your kids participated. That's how they bluffed them. My dad told me on

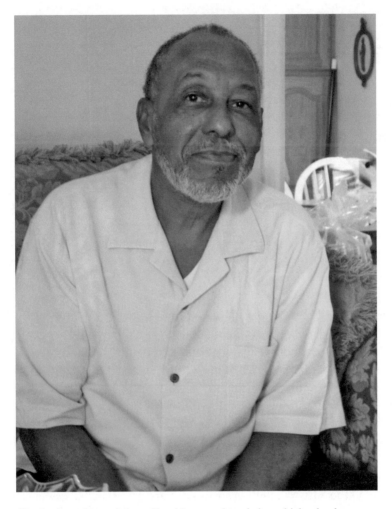

Charles Avery learned that telling his story about being a high school–age civil rights foot soldier now gives him a greater purpose in life.

the Sunday before we were arrested, "That's your decision. I'll take care of myself. You handle this. Whatever you decide to do, you're old enough now to make that decision for yourself."

We had wanted to go earlier, my friend and I. We were hesitant because of the fact that we'd get our parents fired.

And just as he and his friend Harold Booker had experienced similar degradations under segregation, they had also both been stirred by civil rights

leaders determined to bring an end to the separate and unequal conditions that gripped the area. "We had been going to mass meetings for years. We would go. Every Monday night we would be at some church," Avery says. He and his brother and sisters went, driven by their father. "Had he been a younger man, I think he would have participated. He was so focused on making sure that we understood what was happening. We never missed a mass meeting. He would discuss it with us."

Avery and Booker had been watching the massive demonstrations of students who were filling the streets of Birmingham with their nonviolent marches. They had talked themselves into going. And then one day, Hooper City High had a visiting alumnus.

"A young lady who had finished our high school came out to recruit some students from Hooper City, and I was referred to her because I was the class president," Avery says.

> So one of my homeroom teachers asked if I would talk with her. Her name was Annie Peterson. She was a very, very talented young lady—in fact, she's deceased now, I understand. But she got us involved, myself and a friend of mine who was also vice-president. We discussed the matter with her because we had already planned to go. We were going to go down regardless. And after talking to her, she wanted the whole student body.

Miss Peterson did not, however, have the blessing of all the faculty members. The principal of the school, Avery says, called the Jefferson County Sheriff's Department to force her to leave the school on penalty of arrest. The principal—like many other administrators at other schools in and outside the city of Birmingham—did not favor having his students participate in the civil rights marches.

In fact, Avery recalls, the principal tried to stop the student leaders who were standing just outside the school doors organizing the determined would-be demonstrators. But some of the student athletes blocked the door to keep him from coming out.

"May 7, 1963—that was the last day of the arrests. And we were the last school to participate," Avery says.

> We left school about nine, nine-thirty that morning. We had the whole school. There were students just coming in off school buses, and we were able to stand up on the steps and rally them around...We looked back. We had over a thousand people marching down Sixteenth Street.

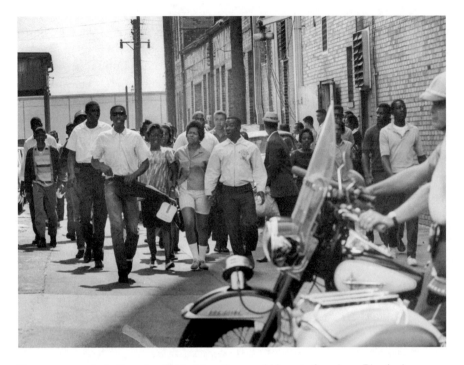

Demonstrators, including school kids, knew they would have to face down Birmingham Police in order to march in the streets in defiance of enforced segregation. *Image courtesy of the Birmingham Public Library Archives.*

That crowd coming up the hill behind the leaders included grade school kids who had left with their older siblings, friends and schoolmates, he remembers. The older students looked after the younger ones.

> *It was well orderly. It was done very peaceful. Until we got to the sheriff.*
> *And we got to the Village Creek on Sixteenth Street out of ACIPCO, and I never will forget, the [deputy] sheriffs were lined up across the road. They had their little batons in their hands and wanted to know who was leading this march, and all hands said, "He is."*

They were, of course, pointing at Avery. He was presented, however, with an unexpected alternative:

> *There was a lady, who was an elderly lady. She was sitting on her front porch in a shotgun house on the side of Village Creek. She came out and*

escorted myself and Booker...through her shotgun house and down the back steps and into the creek. She said, "Run boys, I can't hold them off." We were able to escape, and we got up on Sixteenth Street again. A school bus picked us up and took us downtown, and we were able to tell the leaders there, "We got kids scattered all across that hill out there," and they sent buses to pick them up. And we saw several that we knew coming in...

The county school buses dropped them at the Sixteenth Street Baptist Church, Avery recalls.

When we got into the church, they were already singing and clapping. And man, the speakers! I never will forget James Bevel was up talking, and we were just mesmerized, just mesmerized, with hearing him speak. Then after having gotten all motivated and ready to go, they had little sessions teaching you how to be nonviolent and teaching you songs.

When we walked out, I told my partner that we would stay together, regardless, because we didn't know what we were going to encounter on the street. We would lock hands, and we would stay together and we wouldn't be separated. So we marched in twos.

And soon as we left the steps, we went right into the paddy wagon. And there was Dick Gregory and his writer in the paddy wagon. So we thought that was fun.

They had marched less than a block before they got arrested. "We made the light. We went down the steps, immediately we crossed the street, right into the paddy wagon. That's as far as we got."

Their protest cut short, Avery was among those who went to jail for what he believed. Or rather, he went to the largest of the makeshift detention facilities: the Alabama State Fairgrounds in west Birmingham.

"That experience was one of the most horrible experiences you could encounter," he remembers.

It was springtime, and it was sunshine during the day and cold at night. But a thunderstorm came through Birmingham that evening. It was just about dusk-dark. I mean, an electric storm. The lightning was so intense it would hit the wire, the barbed wire, and it would bounce off. And boy, we were just afraid.

We started singing. We started praying. And I think one of the kids, I never will forget it, he said, "Even God don't want us." But we survived

that evening. And late that night, they started trucking us out. I ended up at the city jail on Southside, Sixth Avenue South. And we stayed there from that Monday till that Friday morning.

He recalls that even though the evenings were cool, the jailers would turn on big fans.

It would actually drop to forty or thirty degrees in there at night. And boy, oh boy, it was cold.

I never will forget the breakfast, the menu. If I get in certain settings, I can smell that stench still in my nostrils today. We had black coffee, applesauce, grits and a hoecake—big, old, you could throw it through a brick wall. For lunch, you would have applesauce, you would have Kool-Aid, some type of bologna. It was meat, but I, to this day, don't know what it was. That taste, you never forget it.

His experiences after the civil rights movement included serving in Southeast Asia in wartime. But to Avery, the Birmingham Jail had been worse:

I have what they call posttraumatic stress from the army. I served in Vietnam. I think that three or four days in jail—since I started talking about it in the last few years has helped me so. I didn't realize that we were suffering all this time until I started communicating with others [about] what happened in the Birmingham Jail.

As a young marcher, Avery had been in jail with no one but protesters. They were packed in tightly, he says:

I'm told that cellblock should have held about 650 people. We had over 1,500 in there that night. That meant we were back-to-back, crammed in. Wherever you could find a sit-down place, you twisted in. There was no bath. The toilet facilities didn't work. And with that many people, you could imagine the stench and the confusion as to what we're going to do. I don't ever recall having to use the bathroom.

I'll never forget that day that I got home…It was an experience just to take a bath.

Before he and his friend Booker were released that Friday:

Our mothers were there in the rain every day...We would pass a little peephole going to eat. And in the morning times, we would get to that hole, we could see the two of them standing at the gate. Other mothers were there. When they went home, I don't remember, but they were there every day in the rain.

Once they were released, the Hooper City students who had protested returned to school to some acclaim, Avery says. "The teachers, they were so proud that Monday morning when we went back to school."

But they—the class leadership, in particular—got a dramatically different reaction from the principal:

This was the end of the school year, and I was a senior—president of the class. And when I went back to school, the principal said—he was against us going, they were just fearful—he said that 'you won't be able to speak.' I was supposed to give the address for the commencement. He told me I couldn't. I had two teachers who lobbied [for him]...One of them was my homeroom teacher, and she [had] encouraged me to go.

In the end, Avery was allowed to speak at graduation. But the principal made sure he did not actually get his diploma, as he recalls. Worse than that, his arrest followed him for years:

When I went into the army, I had to be in a holding area because I couldn't get my orders to leave basic... And they said everybody in there [has] been to jail. And I said, "I ain't never been to no jail." And they said, "You been somewhere in jail." And parading without a permit was the charge.

I went to jump school, and I encountered it again. I'm waiting on orders because I've got to get clearance because I had been arrested.

Avery showed me the official documentation of his pardon, one of the last official acts of former Birmingham mayor Larry Langford, who made a point of pardoning the arrested foot soldiers in 2009 before he was removed from office. (Langford was implicated in crimes committed during his previous role as a member of the Jefferson County Commission.)

Some people at the time thought little of the idea of giving official pardons to civil rights demonstrators from so long ago—including some who had

been part of the movement at the time. "A lot of people didn't want it," Avery recalls. "But I had suffered the consequences of that parading without a permit. I wanted mine."

Participating in the march and getting arrested left an impression on both Avery and Booker. The extent to which it changed things for Booker would become obvious a short time after they returned from jail for the last few days of their senior year in high school.

"The last day of school, we'd all go to the movies downtown," Avery recalls. And we, living in Tarrant, we had to take the bus to Tarrant and get off and either walk home, if we missed the last bus, or take another little jitney or something home. "We got on the bus, I never will forget it— 22 Tarrant. And [Booker] said, 'Ain't sitting back there'." His friend, now having served time for the right to be treated as an equal, was not at all inclined to sit in the back of the bus.

> *I said, "Man, don't start nothing. Come on back here." He said, "I done been to jail now, I want to sit up here." And when he sat up there, the guy told him to move. He wouldn't move. So when he got off the bus—I went out the back door—when he got off the bus, the guy kicked him off. And this guy [Booker]—he would fight...*
>
> *Back then, everybody carried a Case [pocketknife]...The guy closed the door on him. And then here come the police. And everybody, by them knowing our parents, told us to go on home. And my mama got so scared, she said, "Man, you're going to have the Ku Klux coming here." She was fearful.*

Avery's mom felt the need to get him out of town. So she bought him a ticket on the train to Chicago, where his brother lived. "This was June. I left and I stayed until December. It was Christmas when I came back home."

But he didn't stay. He bought a car, moved back to Chicago and did not return to live in Alabama for more than ten years. During that time, he went into the army, and to college and to work in a laboratory as a technician. He had a family. But he never liked Chicago, particularly when it snowed.

When his life changed—"I was on the verge of a divorce," he says—"I said, this is my opportunity to go home."

Within two years of returning to Birmingham, in about 1975, what the civil rights movement had instilled in Chuck Avery came to affect me personally, although, at fourteen, I wasn't fully aware of it at the time. Having become used to demanding his rights—an attitude he had put to good use while

working in Chicago—he was more than willing to speak up for himself when confronted with discriminatory hiring practices back in Birmingham.

So when Avery applied for a position as a clerk in a state-run liquor store, and passed the test to get it, he was not about to accept the position black men were accustomed to accepting even then: that of a custodian. Avery demanded—and got—his clerk's job, opening up the same opportunity for other men who worked at the same store, including my father, who had worked in that store for years without advancement. They became friends and remained so from then on, until my father's death eighteen years later.

Eventually, Avery went into business for himself, first in pest control and then in house painting. A gunshot wound he had received in Vietnam eventually caused him to become disabled. It wasn't until after that when he began to share with others the stories about what he had experienced in the civil rights movement.

The first time he spoke on the subject, he said, it was to a Jewish group from Chicago. That group invited him to travel to Chicago to speak to a larger group, one that also included kids. "I'm thinking it would be a little small place. But this was like an auditorium…It was awesome. It was beyond my wildest imagination," he says.

"But in speaking to those kids, and listening to their question-and-answer period and all, it was like, 'Wow. This is what I've got to do.'"

A month later, Avery gave a talk to a charter school group that came through Birmingham. Students who heard his story gave him their handwritten impressions before they left. He proudly shows them off. "It inspired me," one wrote, "it taught me, it encouraged me. I never knew I could be so inspired to do things like standing up and taking charge."

Since then, Chuck Avery has spoken about the civil rights movement to numerous school and church groups. "I've found," he says, "a *purpose* at sixty-plus years old."

ROSE MARIE COOK

R ecently, Rose Marie Cook moved back to Birmingham, where she had
participated in the civil rights movement. After a few months back in
her hometown, she reached a conclusion: Birmingham still has a long way
to go to achieve what the movement was all about.

Having lived in Michigan and even in neighboring Georgia, Cook sees
Birmingham's post–civil rights era progress as a kind of arrested development.

"To be honest with you, I left Birmingham, and I tried to kind of put
a lot of the things that happened to me out of my mind. I tried to put it
behind me. And then, every time I tried to come back to visit, I would see
there wasn't a whole lot of change in Birmingham. I still don't see a lot of
change," she said.

As she sees it, racial segregation remains a big factor in life more than fifty
years after thousands of marchers fought in the streets to eliminate it. "Once
you've lived in other states, you can see the difference—how far you haven't
really come," Cook said. "Now, if you just stayed here in Alabama, I'm
sure the people here can see a big change rather than me. I still see blacks
separated. Most of my neighbors, when I lived in Michigan and Georgia,
they were white, or either Hispanics or we had a lot of people from India
and China."

In Birmingham, she sees black neighborhoods and white neighborhoods.
And she especially notices that the neighborhood where she came from—
Smithfield—seems to have slid further away from progress economically and
remains as segregated as ever.

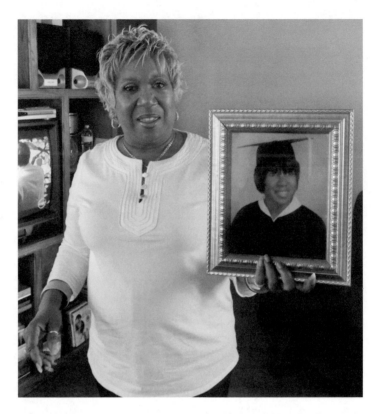

Rose Marie Cook grew up in the Smithfield projects and marched in the streets. She returned home to Birmingham and questions why more hasn't changed.

To be perfectly accurate, of course, Birmingham has changed quite a bit in the period since the demonstrations of Project C in 1963, and much of that change can be traced to the dramatic events of those days. Before 1963, it was illegal for blacks and whites to mix socially or even to share seats in a public conveyance like a bus or a taxi. Today, with that legal barrier knocked down, people live, socialize and, to some degree, even worship across racial lines in Birmingham.

Since 1963, as a result of the truce forged between civil rights leaders and business leaders to desegregate public accommodations and end the mass demonstrations, a group of Birmingham citizens, black and white, have met weekly to discuss the community's common interests. A version of the original Committee on Community Affairs—a direct result of the 1963 truce—still meets every Monday.

Prior to 1963 the all-white power structure of Birmingham, personified by the theatrically villainous Bull Connor, held the city's segregated status in an iron grip, and the "public safety" apparatus was more of a public menace to black residents. That has changed. White and black citizens voted Connor out of office in 1963, and today the Birmingham Police Department is racially integrated and has served under the watch of black police chiefs—including one female chief—for more than two decades.

The fire chief is black, and although that department struggled through a reverse-discrimination lawsuit that dragged on in the courts for years, the racial makeup of the force of firefighters, the passage of time and the political and social changes wrought by the past half century ensure that the days of using water cannons to blast civilians—let alone children—are long over.

Birmingham City Hall, today occupied by a majority-black city government, once used its internal jail cells to hold demonstrations against segregation.

The mayor of Birmingham has been black since Richard Arrington was first elected in 1979, followed by Bernard Kincaid, Larry Langford and now William Bell. Most, but not all, of the city council is black—in stark contrast to the time when Rose Cook marched.

There hasn't been a Klan bombing in Birmingham since the '60s, and succeeding decades saw the terrorists who killed the children at the Sixteenth Street Baptist Church identified and brought to some semblance of legal justice.

It also must be noted that Cook, at the time of my interview, was living in a quiet, racially integrated senior citizens community in east Jefferson County—not far from the city of Tarrant, where several of the foot soldiers quoted in this book reported having intense encounters with the Klan during the civil rights period. Before she marched, that would not have been possible anywhere near Birmingham.

Nor would it have been possible or legal for blacks and whites, without struggle, demonstrations and violence, to attend school together. Today in the Birmingham area, as everywhere else, racially mixed schools are not uncommon. But in the aftermath of the civil rights era, Birmingham city schools and the city as a whole experienced long-term white flight as upwardly mobile or affluent whites left the city educational system and the city neighborhoods they once tried to keep blacks out of, for homes in the suburbs.

Today, blacks with means can do the same, and many have, leaving Birmingham economically and socially poorer. And although there are contingents of young people, black and white, moving back into the city in recent times; a more ethnically diverse population (the state's largest employer, the University of Alabama–Birmingham, lures researchers from across the globe); and efforts to improve the struggling, mostly black, city schools, there remains much poverty in Birmingham.

That is what Rose Marie Cook sees. Her view of the city and its changes might not be expansive or comprehensive, but it represents a view expressed by many foot soldiers and others about how the promise of the movement has not been completely fulfilled.

When her friends here point with pride to their mobility, how they moved from the city proper, southeast down U.S. 280 or to the Trussville community east of Birmingham—all upwardly mobile, growing, economically diverse areas with better schools—Cook thinks people are missing the point.

"When you come back to Birmingham and everybody's talking about 280—'We moved to 280…Trussville'—I'm like, 'What about the inner city?'

Birmingham today wears the scars of its civil rights battles as a badge of honor.

I still see small houses, shotgun houses. I still see the schools still need to be upgraded," Cook said. "Our kids [are] still trying to study out of the same little schools that we were once students at. They just upgraded Parker, I guess, what, about four or five years ago? But the elementary schools—I still don't see a big change."

Cook grew up in Birmingham's Smithfield housing projects, west of downtown. The projects are still there. When she moved back to Birmingham a few months before the interview, she spent some time in College Hills, once a much more affluent neighborhood farther west from Smithfield and directly across from Birmingham-Southern College. Her recollections of tough times under segregation revolve around those areas.

"I just moved from College Hills," she said. "Just living up there grieved me…When I left, I come from Smithfield projects, so we watched [as] white people had to pass our neighborhood every day to go to College Hills and Bush Boulevard. Yet, we couldn't live on Bush Boulevard. We had to live in the projects. And I still see that."

Cook grew up hearing Klan bombings—"We never knew when it was going to be one of us," she said—and experiencing less explosive but daily reminders of oppression. That's a part of what spurred her involvement in the civil rights movement. "I think kids brought up in the projects, we weren't fearful of a lot of things, anyway," she said.

Bull Connor was always in our neighborhood with the policemen anyway. He was always trying to find some reason to mess with the black boys in our neighborhood...For any reason he wanted to, he would harass our boys.

I think he had a car called the "Black Cat" or something like that. But this man was so evil...I remember one year, during the civil rights, he had the electric company come and turn the lights off in Smithfield, and we didn't have any lights at all. Just put us in the dark.

And what he didn't know was, the white people who lived in College Hills and Bush Boulevard had to come through our neighborhood to get home at night. So he wasn't doing us any injustice. He was doing it to them because they needed to see how to get home. We knew Smithfield. We knew it with the back of our hands in the dark. So I think that lasted like a day or two, and he had to have them just go on the pole and cut the lights back on.

Given that, it's no wonder she and other teenagers were primed to rebel when the call went out for young foot soldiers:

At the time we were kids, and we had this deejay called Tall Paul that did a lot of things for the community kids. So he let us know that they were getting ready to do this civil rights movement, and he wanted us all to come out and participate, all the kids. So we would meet up at the Sixteenth Street Baptist Church. Some of us would have to sneak down there. Most of us did.

In my case, my mother was a real quiet person, but she let me participate in a lot of things if it made sense to her, if I could give her a real good reason why I wanted to go. And she let me go.

Cook's mother, like many domestic workers in those days, unable to afford a car, had to depend on public transportation. That meant she had to depend on white bus drivers picking her up so she could ride in the segregated seating available behind the whites-only sign.

"And I think she was sick and tired and fed up, too, with having to run for the bus, that little sign on there, you know, 'for whites,'" Cook said. "Because one day my mom was running for the bus, and the bus driver wouldn't stop to let her on. So she was kind of fed up, too. She wanted to see change."

So Cook, then fourteen, and her brother Walter, sixteen, were able to persuade their mother to let them participate in the movement. Cook started attending mass meetings at night at the church, made acceptable to her mother partly because she knew the kids would be taken care of:

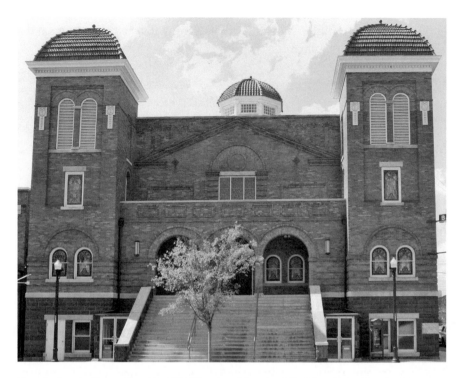

Even before the September 15, 1963 Klan bombing that killed four little girls, the Sixteenth Street Baptist Church was an icon in the Birmingham civil rights movement.

My father and my mom were not together. But his house was right down from Sixteenth Street, a white house across from Poole's Funeral Home that he sold breakfast and dinners out of. So I guess with my dad living down there, my mom knew that the church was close. She really didn't mind us going down there.

The mass meetings captivated young Rose Marie, particularly when King lieutenants Jesse Jackson, Hosea Williams or Andy Young would speak to the crowd. She felt like the young ministers were determined to protect them from any serious harm.

Cook and her brother attended Parker High, a school with a large number of kids who would come to participate in the Children's Crusade. "I remember the day they told us not to go to school—we were excited about that," Cook said. "And some of the kids told me that they cut the hole in the fence and came out to the rally, the march, but I went straight to downtown, my brother and I."

The scene was exciting, she said, with kids from all over converging on the church, ready for the march:

> *I was surprised when I got there and saw Hooper City…to know that all of these kids were going to leave out of school. We thought it was just going to be our little rally. And then to see Carver and West End, and Ullman and all the schools coming together, it started to be like a fun party thing for us. Every day we were excited about something.*
>
> *Our teachers, the ones I had, were very supportive. They didn't talk too much about it, but then they didn't say not to go. That was not true of the principal* [see Gerald Wren's account] *who tried to stop the kids who had come to school.*

Still, on May 3, the second day of the Children's Crusade, Cook and her brother faced Connor's fire hoses. "It felt like something was sticking in my back," she said. "The water was…the pressure was so bad."

But unlike her brother Walter, she did not get arrested. That allowed her to participate in several demonstrations, including the one at Memorial Park mentioned in Carol Jackson Walton's account. Cook remembers it this way: "I was there the Sunday that the water didn't come on. They went to turn the hose on, and the water didn't come on.

"I went to pretty much every march they had in Birmingham while I was here," she said, recalling one in which she succeeded in marching over to what was then Woodrow Wilson Park, between city hall and the Jefferson County Courthouse.

Her activism came with a price—although she did not know it at the time. Her mother had been the maid for a prominent family who owned a furniture store. After the protests, "she lost her job because her children were part of the march," Cook said. "She didn't tell us that, but we figured it out."

One of the events of that time with great impact was also one that Cook missed in a sense: the Sixteenth Street Baptist Church bombing on September 15, 1963. "When the bomb went off, we had left to go to Selma," she said. "I had never been past Birmingham before, so we went to Selma to visit some relatives we had there, and on our way back, they had newspaper people all in the middle of the street talking about the bombing."

But although she was not among those injured in the blast, it touched her, as it did many from the Smithfield community. She knew the children who were killed in the bombing. "Carole's mother, Mrs. Robinson, was my music teacher. And she taught me cursive—how to write without printing

everything. And that's how I knew Carole and Cynthia [Wesley]…because we went to the same elementary school together," she said.

Cook recalls that children, traumatized by that event, had to learn to grapple with the resulting emotions the hard way:

> *We were flower girls at…the girls' funerals at Sixteenth Street. When we went back to school, we didn't talk about it. We didn't talk. We didn't talk about this bombing at all, to the teachers, to the principal. We didn't have counseling like the kids have now. We didn't talk about it. It was like it never happened. In our minds, we knew it, you know. You long for them, and you miss them, but we didn't have anybody to go talk to about how we were feeling on the inside.*

She moved from Birmingham in 1967 and quickly discovered that much of what had happened in Birmingham during the height of the movement, or at least the significance of it, had gone largely unnoticed by people she encountered:

> *I told people about it when I lived in other states. But it was pretty much hush, hush…It's like people really didn't know what we went through here in Alabama, being black—until maybe recently…*
>
> *I remember when I first went to Georgia in '67 and we would tell people that we were part of the civil rights movement, people would treat us like they didn't have no clue of what the movement was about. And you know how you finally want to talk about what you went through and all the things that happened to you? Because it wasn't publicized enough, people had no compassion for us at all.*

And once she moved away, Cook lost touch with Birmingham as she tried to put the past behind her. She was unaware, until I told her, of the eventual outcome of the Sixteenth Street bombing. "I always wondered, whatever happened to the men that did the bombing…When you live in another state, they don't show all this stuff on the news."

She moved back to Birmingham in 2013 as the city was wrapping up a several-months-long commemoration of the events of 1963. One of those events included the unveiling of a statue of the four girls who died in the bombing, as well as two African American boys who were shot to death in separate incidents on the same day. The statue, on the corner across from the Sixteenth Street Baptist Church and the Birmingham Civil Rights Institute,

is called *Four Spirits*. "That's who they were," Cook said. "They were angels. I mean, Carole and Cynthia—to know them was to love them. Oh, my God."

The movement changed her, Cook said, making her more willing to stand up for her rights:

> *It made me be strong. And it made me not to bow. I thank God for that. By the time I got to Michigan, I saw all white people as different. So I'm going to treat you like you treat me. But I know how to treat you when you stop treating me like I want to be treated. Because that fear that I went through as a kid, it toughened me up. A lot of things that they could have done to us in the civil rights movement—they didn't.*

As she looks back, she thinks the opposition might have been more afraid of the demonstrators than the other way around. "Our mothers couldn't do it, or our fathers. But I think it [scared] them to see all these little black kids out here, not afraid of going to jail…I think they had more fear in them than we did. And it helped me in life."

Because of that, Cook said, she has been willing to talk to young people to help them see that they owe a debt to those who came before. "You just

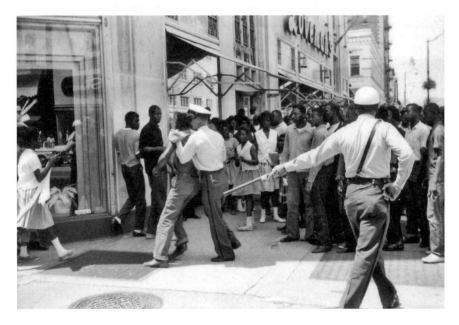

The Birmingham Police arrested thousands of civil rights demonstrators on the streets of Birmingham and, by doing so, overcrowded the jails—just what the movement needed. *Image courtesy of BCRI Archives.*

didn't get this job because you got this education or you got a master's or a bachelor's," she said. "Somebody paved the way, and if you don't know anything else, you need to know all the people pretty much who fought and died for you to have this."

More than that, she said, "the kids need to know that there's power in numbers."

But Cook is just as determined to stand up for her rights without hate, a mindset that required some soul searching. "I tried not to put as much focus on what they did because it would do more to me than them," she said.

> *Some things you have to let go. I couldn't do anything about it. I was a kid then, and I couldn't understand - why would somebody be so hateful?*
>
> *But then I realized hatred is something that is taught. They didn't just wake up one day and say, "I'm gonna start hating black people." They were taught this. So they were a product of what they were taught. We were a product of what we were taught. And we were taught to love everybody, in spite of what they we doing to us—love them.*

Now she has returned to Birmingham after many years, hoping to learn more about what she missed and hoping to change the things in the city that she sees as still needing change:

> *Now that I'm here, I want to know it. I want to see some change. I prayed—God knows I prayed—I said, "God, I don't want to go back to Alabama…Until I see a change."*
>
> *I don't know what God has for me now. But with this happening, I was saying, "Wow. Maybe this is my reason for being back here: to be part of the civil rights movement, to get active, to get busy, to get something going."*

LEROY STOVER

In any war where there are foot soldiers, there are also civilians. In some cases, after the war ends, civilians find that aspects of their lives have improved. Such was the case in Birmingham, where the masses of foot soldiers were never the majority of people affected by segregation. But in the aftermath of the Birmingham movement, many of the civilians benefited with improved living conditions and opportunities they had previously been denied.

One change for which civil rights organizers had pressed in Birmingham, particularly in the negotiations that actually began before the demonstrations of Project C, involved changing the makeup of the Birmingham Police Department. Under a diehard racist like Bull Connor, the idea of having a nonwhite police officer was outrageous, and far out of the question. But with segregation legally crushed in the period following the protests, civil rights leaders eventually got their wish.

In 1966, Birmingham hired its first three black police officers. The very first of them was a man who had completely avoided involvement in the civil rights movement and who actually had no interest in becoming a symbol of what the foot soldiers had fought for. His name is Leroy Stover.

As Stover tells his story, you get the impression that he was probably selected precisely because of his noninvolvement with the movement. It seemed that the powers that ruled the city did not want anyone with strong ties to the movement leaders to wear its uniform—even though Connor was long gone. And that description—"not involved in civil rights"—certainly fit Stover and Johnnie Johnson, who became the second black officer hired

on the force (although Johnson had worked in civil defense, a uniformed position that allowed him some authority at times, in the black community).

Ironically, by the time they ended their long, distinguished careers in the police department, Johnson had risen to become its first African American chief and Stover its first black deputy chief.

I interviewed Stover about his story in late 2013 for *Weld*, a weekly Birmingham newspaper. The occasion was the publication of a book about him, written by his niece. For my interview with Stover, we focused on his first day on the job. The following story, or a form of it, appeared first in *Weld* on November 28, 2013.

Why retell it here? If you think about it, Stover and those who would come after him were an important part of what the foot soldiers were fighting for. His tenure on the Birmingham Police Department is, in a very real way, a part of their legacy.

Birmingham's civil rights history neither began nor ended in 1963. It was a story with many chapters, some taking place before the pivotal events of fifty years ago and some afterward. But those events played an important part in bringing about change in Birmingham, including the integration of the city's all-white police department. That came in 1966, with the hiring of Stover.

Today, Stover and his wife live a quiet life in a well-settled Birmingham neighborhood on the west side of town, the West End. He is a friendly man; the day I went to visit him in 2013, he came out of the house and bounded down his steep driveway like a man half his age to give directions to a couple who had gotten lost looking for a funeral. (His wife actually got in her car and drove to where the errant mourners needed to be, to make sure they got where they were going.)

Stover is the kind of retiree who spends hours making artwork for his yard. He gave me a small replica of the Tin Man from *The Wizard of Oz*, painted silver, constructed by hand from soup cans and sardine tins, with articulating arms and legs and a wire coat hanger to suspend it for display. The artist, who insisted that I take the creation, smiles with a broad grin that bears no hint of bitterness when he tells how he first joined the police department. In fact, when he tells the story—one that includes the hateful treatment he suffered from day one in the BPD—he actually finds humor in it.

Stover was both catalyst and eyewitness to what must have been a shocking transformation over those thirty-two years. He saw what had been segregationist Connor's police department turn into a force with black

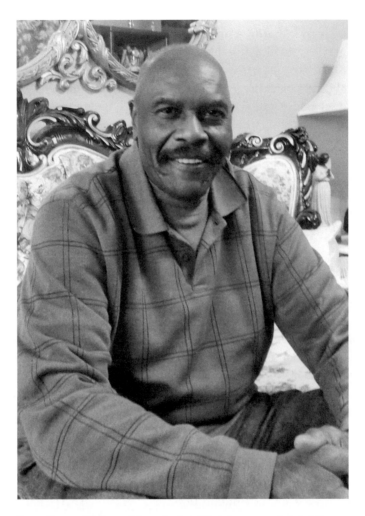

Leroy Stover didn't participate in the civil rights movement, but he became the embodiment of one thing the foot soldiers fought for as Birmingham's first black cop.

officers in the highest ranks. (Stover retired in 1998 as deputy chief, shortly after Johnson retired as police chief.)

Much of Stover's experience is recounted in a recent book, *Leroy Stover, Birmingham, Alabama's First Black Policeman: A Three-Decade Perspective*. The book was written by Stover's niece Dr. Bessie Stover Powell, an associate professor of education at South Carolina State University. The occasion for my visit was that Stover was due to sign copies of the book at the main branch of the Birmingham Public Library.

Despite his good-natured retelling of his story, though, Stover admitted that integrating the Birmingham Police Department was "hectic and very stressful."

To be the first black man in a Birmingham Police uniform was serious business in the mid-1960s. The department, which had been directed not too much earlier by Connor, the notorious commissioner of public safety, was still known to have several officers who were members of the Ku Klux Klan.

Before Stover became a cop, he didn't want to be a cop. He was a truck driver and office worker for a company called Pratt-Ensley Building Supply in Ensley. While making his deliveries in the company truck in 1963, Stover saw the massive civil rights demonstrations and "witnessed the dogs biting people and the water hoses and that sort of thing from the sanctuary of my truck."

He never got involved in the protests that were rocking the community. But three years after the Birmingham movement, Stover's boss, "a very pious, religious guy," encouraged him to become one of its beneficiaries by applying for a job at the Birmingham Police Department.

A main goal of the 1963 movement had been to desegregate the city's public accommodations, the "up-grading of employment opportunities available for Negroes, and the beginning of a non-discriminatory hiring policy." While much of the thrust was on hiring within businesses, the Birmingham movement's Central Committee had also been working to integrate the city police department.

The demand, "hiring Negroes to [the] police force," was included in the "Points for Progress, Birmingham, Alabama," a four-item document presented by members of the movement to a committee of businessmen "representing the white community of our city," as noted in the book *Minutes: Central Committee 1963*.

But by 1966, that had not been done. In fact, blacks, sponsored by the movement and Miles College, had been repeatedly told they did not qualify to become police officers in the city of Birmingham. "Of course, the personnel board and the police department summarily turned them down," Stover said. "Some passed the test. Some didn't pass the test. But these people had been sent by civil rights groups and black colleges, so as a result, actually, they were going to be turned down whether they passed the test or not."

Stover represented a new option, precisely because he was not sponsored by the movement or a black college. "So my boss and I talked about it. Since I wasn't affiliated with civil rights groups and I wasn't a college graduate at the time…he said maybe I'd stand a chance."

Stover was anything but enthused by the opportunity:

> *I didn't really want to go down and take the test because I had been in Birmingham ten years. I knew, I was aware of the atrocities committed by racist Birmingham Police toward blacks in general and black males in particular. And then, I had been mistreated by white police officers myself.*

He passed the test. The department's background check on Stover showed no arrest record and no affiliation with any civil rights group, and Stover became the first black police officer in Birmingham.

But that didn't mean that either the brass or the rank and file really accepted their new "colored" officer. Consider the sequence of events on his first day at work, March 30, 1966.

After his physical and picking up his uniform at the police academy, Stover had been told to report three days later—not for training, but to go right to work. "I had been told to report to the police academy, and two superior officers were going to escort me to city hall where roll call was going to be held. I was to leave my car at the police academy," which, on Sixth Avenue South, was miles away from Birmingham City Hall on Nineteenth Street and Eighth Avenue North.

He was supposed to work the 3:00 to 11:00 p.m. shift and reported to the academy a little before 2:00 p.m. Two captains showed up to drive him to city hall. As they approached city call on Nineteenth Street, Stover said, there were crowds of people lined up to see him, having learned, possibly through the news media, that Birmingham's first black officer would be reporting for duty that day. Blacks, he said, were primarily on the west side of the street, while a mostly white crowd occupied the sidewalk on the eastern side, adjacent to city hall.

As the crowd near city hall surged toward the approaching police car, the captain who was driving increased speed down into the driveway of the underground parking lot beneath the building. That garage, which allowed police cars to drive in and back out without turning around, was called, Stover said, "the runaround."

He and the two captains walked through glass doors into a long hallway toward the large roll call room, and Stover could see as many as eighty white cops, by his estimate, standing around and watching. But as he approached the room, both of the escorting captains exited upstairs and "left me walking down the hallway by myself," Stover said.

I had about fifty or seventy-five feet to go alone. I could still see down the hallway at all these officers, and they started looking up the hallway and going, "Hey—here comes a nigger. He's got a police uniform, and he's got a gun." So I wouldn't dare put my hand near my gun. I just continued to walk.

Stover walked into the roll call room to the catcalls of racial slurs from the white police officers. "As I got closer, they said, 'Who's going to work with that nigger today?' and they started pulling their guns out of their holsters and blowing imaginary smoke off the barrel."

As he entered the room, all of the officers moved to one side. "I had the whole half of that large room by myself," he said. "I kinda thought for a minute that maybe I'd just move over close to them, that maybe I would push them on out of the room. But I said, 'Better not press my luck.' I gave up that idea right quick."

The white officers continued jeering until the senior sergeant called the room to order for the roll call, Stover said. Stover was assigned to work car sixty-three with an officer—he preferred to identify the officer only by his initials, D.M.A., although his niece's book identifies him more fully—who was known, Stover said, for his racist views. That officer, Stover's partner, was not in the room, however.

All the officers left roll call and went back to the runaround, where someone drove their patrol cars to them, allowing them to head out from city hall to their beat assignments. All the officers, that is, except one:

I saw cars numbered fifty-four, fifty-six, sixty-two, sixty-four…everything but car sixty-three. And so finally there were no more cars coming in, and all the officers who had been assigned had taken a car and gone. I was the only one left standing out there in the runaround.

Stover waited a few minutes more for the partner and car he figured at first must have just been running late.

"But unknown to me," Stover said, "car sixty-three didn't come into the runaround to make relief. It made relief out on the beat." That beat relief spot was on Third Avenue and Thirty-fifth Street South—miles away—which nobody had bothered to tell Stover.

So Stover, having no patrol car, walked back down to the roll call room and spoke to the same senior sergeant who had presided over the roll call. In recounting what happened next, Stover refused to use the profane

language his sergeant directed toward him (although his niece's book gives the terminology in detail). "He was using expletives. 'What the blankety-blank are you doing still here?'" Stover recalled. That's when he told him he needed to go find his car on the beat and gave him a warning: "'If you don't get your black blankety-blank-blank over there in twenty minutes, I'm going to write your black blankety-blank-blank up for being AWOL.'"

Stover protested that he didn't have his car to drive out to the beat; he had been instructed to leave it at the police academy, a fact that did not faze the sergeant. "He said, 'Well, ain't that just too d--- bad?,'" Stover said.

Faced with the prospect of getting written up—and probably kicked out—on his first day on the job, Stover had to figure out a way to get to his partner and patrol car. So he decided to walk across the street from city hall to the Greyhound Bus station. The crowds of people who had been waiting to see him were still standing on both sides of the street, he said, "waiting for the first colored policeman to come out of the runaround in a car." When, instead, he walked out, Stover said, it created quite a stir. "There's that colored police," he heard repeatedly.

A friendly white bus driver not only picked him up but also took him off the route—the bus was supposed to be bound for Titusville, southwest of downtown—to the police car near Avondale. "Sure enough, there was car sixty-three sitting up under a tree, with a white officer behind the wheel with the motor running," Stover said. When Stover got off the bus, the driver said, "'You be careful out there. There are a lot of them that don't want to see you here.'"

His partner, D.M.A., not only wouldn't speak to him but also, as Stover was stepping into the car—with one foot still on the ground—gunned the engine and took off at a high rate of speed. When Stover protested, "he said, 'If you can't stand the heat, get out of the d--- kitchen,'" Stover recalled.

During that shift, the officer wouldn't let Stover hold the report clipboard and refused to stop at a restaurant to eat dinner with his black partner. Instead, they ate from a service station vending machine, Stover said.

"I found out later that he was the worst racist on the police department. They put me with him so he could get rid of me on the first day."

In fact, Stover said, the partner made his intentions clear every time someone took note of the race of his rookie. "They'd say, 'D.M.A.'—they knew his name—'you got that nigger with you today.' He said, 'Yeah, they put that nigger with me today. But he ain't going to last long.'"

Of course, he was wrong. Stover endured the indignities of that day and many to come. And not entirely without help. Not all the white Birmingham

Police officers fought so hard to make him quit; some, in fact, encouraged him privately to hang in and endure. Some white officers even helped him get promoted by providing books he could not get otherwise, books he studied before taking the officer exams. "They had to get used to it. Most of them became reconciled to the fact that I was there—that blacks were there."

Still, in many ways, the resistance would continue.

For example, Stover said, about eight months into the job, when he, Johnson and the third black officer, Robert Boswell, were finally in training at the police academy, two men in Klan hoods burst into the classroom firing guns and yelling, "'Run, nigger, run!" It turned out to be someone's idea of a joke—the Klansmen were Birmingham officers, and the guns were firing blanks.

It was no joke later when Stover and Johnson were working undercover and cops who were taking bribes from the owners of illegal shot houses gave the names of the black officers to the criminals, endangering not only the investigation but also their lives.

At eighty, Stover has a lot of stories, but they include the story of how the Birmingham Police Department eventually changed and how, along the way, its first black officer earned both the respect of many of his colleagues and promotion after promotion until he achieved the second-highest rank on the force.

"I think it was very fruitful," he said. "I was satisfied. At the end of the day, I felt that I touched somebody, that I made a difference in some areas. And I felt satisfied that I did the best I could do…I have no regrets."

EPILOGUE

During the course of writing this book, someone threw an idea at me that needed time to settle in, possibly because, at the time, I was knee-deep in a looming deadline. But now that I've nearly reached the end, the notion has bubbled back up to the surface.

What happened in Birmingham between 1947—the time of the first Klan bombing in the city's Smithfield neighborhood—and 1963 would make for a really good movie. I'm talking big-time, Hollywood epic.

It would not need to be fictionalized to make it exciting, just condensed. Think about it:

In the wake of terrorism and government-sponsored oppression, a stubborn resistance movement arises, first led by a tough young minister whose belief in his cause is absolute, who is convinced that he is on a mission ordained by God, whose conviction that he is invulnerable is cemented for him and many of his followers when the terrorists bomb his house and fail to hurt him. As the movement grows, the resistance makes bolder and bolder moves, enduring constant dehumanization, more bombings, harassment, physical assaults and, eventually, murder.

They face setbacks, and when the odds turn against them, another, more famous resistance fighter joins the fray, bringing his young lieutenants with him. The formerly demoralized rebels are mesmerized by the charismatic leadership. A bold—some would say reckless—plan is hatched to throw seemingly vulnerable men, women and, finally, children directly into the path of the enemy's hateful juggernaut, a nearly monolithic force armed

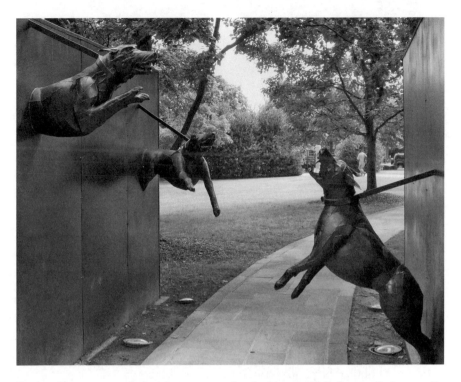

To give visitors a sense of what demonstrators faced, visitors to Kelly Ingram Park can walk through this gauntlet of snarling police dogs lunging out of their steel walls.

with guns, batons, assault vehicles, water cannons and snarling canines, all led by a petty, small-minded dictator in a custom-built, menacing tank.

And from there, it's just the stories—the compelling individual stories behind and making up the bigger story—stories of faith, fear, heroism, villainy, conflict, disappointment, victory and, finally, change.

The true story of what happened in Birmingham's civil rights movement needs no embellishing; it's got every element it needs. But it does need to be told. And that's what I endeavored to do here, at least in a small way. It seems quite likely that even many people who grew up in Birmingham might be only slightly aware of the significance and the scope of the history that was made in this city.

I say that because that was true for me. Growing up in a Birmingham suburb, I was a toddler in 1963, and I have no recollection of the momentous events that were going on just a few miles away. I do remember segregation slightly. I was halfway through the third grade when the schools in Homewood, where I lived, integrated. I have a clear memory of what it

was like in the late '60s to go from the all-black Rosedale school to the no-longer-all-white Edgewood Elementary. It still seems amazing to me that I could have grown up so close to where history was made and to have known so little about it. I didn't start appreciating the importance of some of the stories of how integration came to Birmingham until I was already working as a newspaper reporter many years later. To me, those first stories about the foot soldiers were a revelation on many levels. They still are.

The truth is, there are so many stories to tell of the incredible sacrifices of those days that I have barely scratched the surface. As mentioned earlier in this book, this is hardly the first or most comprehensive telling of those events. This is an effort to get at just some of the stories, mostly untold, many unknown outside the circles of activists and movement survivors, interested historians, sociologists, students, writers and other journalists.

For me, this represents a continuation of the effort I began years ago at the *Birmingham Post-Herald*, when I first really began learning about the foot soldiers in the civil rights movement. Back then, I had the opportunity to interview Fred Shuttlesworth, Myrna Carter Jackson and James Armstrong (his particular role in the movement has been documented in the award-winning film *The Barber of Birmingham*).

Armstrong, who was still involved in civil rights causes when I interviewed him in 1998, had met the bloodied Freedom Riders when they arrived at the Birmingham Trailways bus station in 1961, had carried the flag in marches from Selma to Montgomery and had sued the city to integrate Graymont School with his two sons. He also told me that his daughter had narrowly missed being caught in the most horrific act of violence during the civil rights era: the Sixteenth Street Baptist Church bombing. He had asked Carole Robertson's mother to pick her up and take her to church that day, but for some reason, she didn't.

A businessman to his core, Armstrong said owning his own was a major motivator in his joining the movement. He said he just wanted what the freed slaves had been promised. "I always wanted my mule and forty acres. So I got in the fight. I'm still in it today," he said.

Armstrong is mentioned a little in this book—too little, arguably—but the *Post-Herald* also gave me the chance to interview other people who did not make it into this book at all.

LOLA HENDRICKS was the first corresponding secretary of the Alabama Christian Movement for Human Rights. She told me in 1999 that attending mass meetings and listening to Martin Luther King taught her something critical, although she had been a civil rights activist by that time for years.

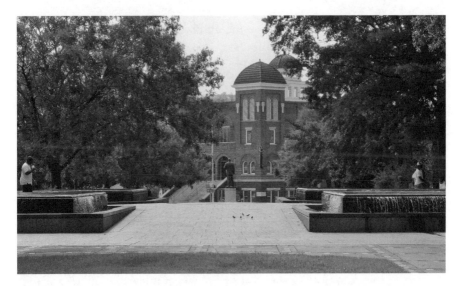

Kelly Ingram Park, in the heart of Birmingham's Civil Rights District, offers pedestrians a view of important movement monuments like the Sixteenth Street Baptist Church.

"The most important thing that happened during the movement, and it affected me," she said, "was to see nonviolence in action. It taught me you could become nonviolent."

She also described following King's instruction to go directly to Bull Connor and ask for a permit to demonstrate in the city. She found the notorious public safety commissioner in city hall and made her request. "He said, 'I'll demonstrate you over to the city jail. I'm not going to give you anything,'" Hendricks remembered. Connor struck no fear into her, she said. "I wasn't afraid of anything. I felt we were being treated so badly, I was willing to die if I had to…We wanted this city to be a better city than it was for us."

AUDREY HENDRICKS, Lola's daughter, was just eight years old when she was arrested for protesting segregation in Birmingham. Although she had attended the mass meetings with her activist parents and her father had lost his job for demonstrating, Audrey decided for herself to join the marchers and left Center Street School without the permission of either administrators or her folks. "I went by the school and told the teacher I was going to jail," she told me. She spent five days locked up at the juvenile detention facility.

ANNETTA STREETER GARY was a sixteen-year-old Ullman High School student when she joined the movement. She told me, "I was just so caught

up in it. I felt like this was history being made. This was something that had to be done." Gary was blasted by the water cannons and jailed twice for sit-ins and marches. When a jail matron, who apparently thought the light-skinned Gary was white, asked why she was there, Gary simply replied, "I want my freedom."

NETTIE FLEMMON was a feisty eighty-year-old when she talked to me in 1999. Flemmon told me about being there at the founding of the ACMHR on June 5, 1956. "I just made up my mind that it wouldn't be fair for me not to participate in it [the movement] because it was concerning us and I couldn't control my peace." She never missed one of the Monday night mass meetings, she said. "I was there, baby, rain or shine."

Flemmon said that three of her children had been arrested in one of the Children's Crusade demonstrations. And she herself had taken to the streets on more than one occasion. One time, while walking a picket line, Flemmon got arrested. "They arrested me for grabbing a lady's tennis shoes," she told me. The victim of her crime was another black woman who had been shopping at one of the downtown stores despite the boycott. Flemmon decided to turn the other woman into a lesson to any blacks who didn't support the boycott. "I was going to throw [the shoes] across the street"—a clear violation of the general nonviolence marchers were striving for. But she got arrested before she could complete the deed. "I just jumped the gun," she said.

There were so many more foot soldiers I never got to interview. I met COLONEL STONE JOHNSON many times and, regrettably, failed to truly understand, before it was too late, how big a role he played as a diehard foot soldier, at least once risking his life (along with WILL HALL) by moving a dynamite bomb away from Shuttlesworth's church before it all went off. Many people know Johnson's history, though. Considering the thousands who participated in the marches, sit-ins, pickets and other demonstrations of civil disobedience to end Birmingham's official segregation, there are those whose stories might never be heard. At least that is true in the individual sense. For many of those unheard voices, the ones represented here might hold a note of familiarity. All of the foot soldiers have a sort of kinship, after all, a brotherhood and sisterhood forged in an unusual battle unlike any fought in that way anywhere else in America.

So this short list that comprises the representative sampling of foot soldiers who fought the battles of Birmingham is admittedly not complete. I did try to give a reasonably balanced accounting gender wise. More than one commentator has pointed out that women and girls made up a significant

The courtyard of the A.G. Gaston Motel in 2013, site of the truce between the forces of King and Shuttlesworth and city business representatives.

Opposite: Today's Birmingham has embraced its turbulent history. Markers like this stand to educate visitors about the movement demonstrations and show where protesters once walked.

portion of the foot soldiers as a whole. "The women involved hardly get enough credit, but they did as much of the day-to-day work, like Georgia Price and Julia Range and Lola Hendricks," Diane McWhorter said. "I guess they would be foot soldiers, but they would also be more than that. They were really good. They were the organizing engines of the movement."

So many stories, so little time to tell them. In the end, I hope sincerely that I did justice to the ones I got to share.

There are other places to learn stories about various foot soldiers. Among them is the Birmingham Civil Rights Institute, which, besides featuring living foot soldiers in its programming year after year, maintains a notable selection of oral histories of people of all categories who participated in the movement and offers dozens of interview clips on its website. And a series of interviews with foot soldiers and others makes up an hour-long video released in 2013 called *1963: The Year That Changed Everything as Told by the People Who Were There.*"

EPILOGUE

And it is worth noting that as I write this, the city of Birmingham is slated to display a new monument to the foot soldiers to coincide with the 2014 anniversary of the Sixteenth Street Baptist Church bombing. In the document calling for a national design competition for the monument, Birmingham mayor William Bell significantly said:

> *The foot soldiers were students, laborers, housewives and others who filled in the battleground, namelessly, behind the more celebrated leaders. They are in the history books, waving pickets, ducking water hoses, but never with a page of their own, and that's the reason for this competition, to recognize these fearless individuals for their heroic efforts.*

INDEX

ABOUT THE AUTHOR

N ick Patterson has been a writer, editor, teacher and media relations and communications consultant for more than thirty years. He currently edits a weekly newspaper in Birmingham called *Weld*, specializing in hyperlocal long-form journalism, and writes freelance magazine articles for clients including *History*, the print adjunct to the History Channel. He has been director of communications at the Birmingham Museum of Art, an editor at *Southern Living* magazine, a daily newspaper reporter at the *Birmingham Post-Herald* and an adjunct instructor in journalism at the University of Alabama–Birmingham.

Visit us at
www.historypress.net

...

This title is also available as an e-book